THE ART OF CARTOONING

THE COMPLETE GUIDE TO CREATING SUCCESSFUL CARTOONS!

David Mostyn

ARCTURUS

David Mostyn *was born in Yorkshire in 1944. After finishing school in South Africa, he went to art college and then straight into advertising. He spent ten years as an art director in agencies and studios in London. After a short spell in publishing, he set up as a freelance cartoonist in 1978. He has worked for* Mad magazine, The Beano, The Dandy *and* Marvel Comics, *and has illustrated many books, magazines and advertising campaigns. He is married with two children, and lives in Oxford.*

ARCTURUS

This edition published in 2010 by Arcturus Publishing Limited
26/27 Bickels Yard, 151–153 Bermondsey Street,
London SE1 3HA

978-1-84837-566-6
AD001299EN

Printed in Singapore

THE ART OF CARTOONING

CONTENTS

INTRODUCTION

This is a book about how to put a cartoon together. There are a few very basic rules, and if you spend a bit of time getting them right, it'll make your trip into the world of cartooning a great deal easier. Cartoons are very diverse – they can be witty, satirical or just downright funny. You can use them to make political points or joke about your friends. As long as you get your message across, it's just a matter of experimentation. Look at what other cartoonists draw, and how they draw it. Copy their styles and techniques. The more you look and copy and practise, the more you'll become accustomed to this method of drawing.

I hope this book will give you a platform on which to perform. As with any of the arts – and I do class cartoons very much as an art form – the more you practise the more you'll achieve. Practising doesn't have to mean sweating away in a studio surrounded by expensive equipment. All you need is a sharp eye, a bit of pencil and the back of an envelope. You'll have to try to be very observant. Watching life go by is hugely entertaining. The cartoon ideas are there in front of you. All you have to do is to be aware of them.

A simple, everyday scene can, by distorting the action, easily be made into a cartoon. Cartoons are after all, simply a distortion of reality.

Look through this book. There are plenty of avenues to go down. Have fun with it, agree with it, or disagree with it. Just use it to open the doors into this very weird and eccentric world.

MATERIALS AND EQUIPMENT

The range of artists' materials currently on the market is overwhelming. Over the years I have spent what must amount to a smallish fortune in paints and pens, some of which have been discarded. However, these weren't a waste of money as they helped me to sort out which materials suit my style of artwork.

Before you go to an art shop, try to decide on the kind of work you want to do, then concentrate on finding the materials that will be suitable for it. Inevitably you will buy some products that you find don't work for you, and as you progress, like me, you will discard equipment along the way. The most important point to remember is that there are no hard and fast rules in the cartoon industry on what you may use as your drawing tools.

My equipment is very simple, and I describe here what I use and why.

PAPER

There are basically two types of paper surface suitable for drawing cartoons: Hot Pressed (HP) and NOT, sometimes termed Cold Pressed (CP). NOT paper can be quite rough to the touch and has a definite texture, while HP paper has a smooth surface. Some brands of paper are obtainable in both forms.

Because you may want to draw in different styles and mediums, in black and white and in colour too, it's useful to find a brand of paper that suits all these things. Fabriano paper is suited to just about everything you can throw at it, both literally and figuratively. Leonardo da Vinci used it, and I feel that what's good enough for him is good enough for me!

I favour Fabriano 5, which comes in both HP and NOT surfaces; which you choose depends on your individual style. A weight of 300gsm (140lb) is excellent when it comes to supporting heavy inking and colour. It is reasonably priced, and if you can buy it in bulk, so much the better. Fabriano also has excellent see-through qualities which you will find useful.

Bristol board is a very smooth, hard paper ideal for more diagrammatic fine-line black and white cartoons, but it's not very good for colour. For ideas and roughs, I draw on very cheap 80gsm (20lb) paper. Experiment with different papers and you'll soon find out how their surfaces react with different drawing tools.

PENS

There are several different types of pen available, all with their own characteristic marks. I use felt-tip pens a great deal as they are excellent to draw with. They are easily available and inexpensive, but make sure you buy the waterproof variety.

Dip pens are the old-fashioned type of pen, where you insert a nib into the ink holder. They can be tricky to use at first, but with practice you can draw wonderfully variable lines with them. A 303 nib is a good standard nib to begin with. Make sure you use waterproof ink.

Rapido pens are generally used to draw detailed diagrams or fine line work. They produce a line of even width and are available in different thicknesses.

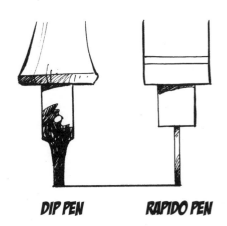

DIP PEN **RAPIDO PEN**

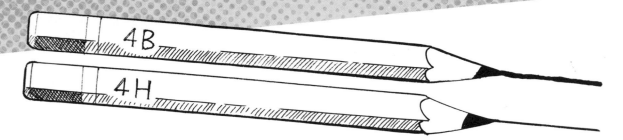

PENCILS

Pencils are sold in varying grades from 6H (the hardest) to 6B (the softest). As you might expect, HB falls in the centre. The grade is indicated at the non-business end of a pencil (when you sharpen your pencil, please remember to do it at the opposite end!) I always use a 4B, which gives a good black line.

PARALLEL RULERS

These are mostly found on the larger drawing boards such as you might find in an architect's office. However, some years ago I discovered a small plastic 300mm parallel ruler that is ideal for putting in guidelines and drawing reasonably accurate square boxes. It looks a bit gimmicky, but it really is very effective, and now I can't work without one. They are available in most art supplies shops, and are very reasonably priced.

ERASERS

Putty erasers are the only kind to use – they are very soft and will remove pencil marks from the paper without damaging the surface. Inflexible 'school' erasers will spoil it.

'SCHOOL' ERASER

PUTTY ERASER

BRUSHES

Brushes come in varying sizes and types of hair. At the top end of the market, sable brushes are the best and most expensive. I have never bought them because as a cartoonist I use a great deal of black ink and however hard I might try to keep them clean, a residue of ink would build up in them and eventually make them unusable. Instead, I lean towards the synthetic type of brush. They don't retain as much water but they are a great deal cheaper than their aristocratic chums and perform just as well.

The size of a brush is indicated by a number – the lower the number, the smaller the brush. For everyday purposes I use a No.1 and No. 5 round brush, though when it comes to putting on larger areas of wash it's better to use one from No. 8 upwards. I find the very fine point that round brushes have gets in the way, so I trim the brush with a scalpel blade, cutting it on a very hard surface. Although the piece removed is minuscule, I find the brush easier to control. I have two sets of brushes, one for colour and the other for black and white.

COLOURED MEDIUMS

Colouring cartoons is entirely different to painting a picture on canvas or board. Cartoon colour tends to be bright, sharp and very hard, and should be water-based for fast drying. The traditional watercolour pans give a good clear colour but tend to be rather weak; inks and dyes give a much crisper result. I use inks, which dilute very evenly and aren't too quick-drying. Some colours have to be diluted with distilled water because if you use ordinary tap water the colour separates out and will leave a sediment on the paper.

Acrylics come in a splendid range of brands and colours. They do tend to dry very quickly, and are more suited to a painterly approach as opposed to the normal wash technique. Marker pens, available in a huge range of colours, are ideal for doing colour roughs, or for more casually drawn cartoons. Crayons are not much found in cartoons, but they can give a wonderfully soft effect and are generally used in children's publications.

If you progress to drawing cartoons professionally, one very important point to remember is to use a long-established manufacturer. For example, if you are doing a long-running cartoon strip you might have trouble finding similar colours in the event that your manufacturer ceases production.

DRAWING SURFACES

You can buy drawing boards from art supplies shops, but there's no need to – a piece of 12mm MDF from a DIY store will suffice. That is as simple and low-tech as it gets, but at the other end of the scale a valuable piece of technology available to the modern artist is an electronic drawing tablet; this offers you the facility to copy your work to your computer by direct connection. You can then print it out as many times as you like, or amend it in Photoshop (see pages 118–125).

To trace rough drawings from your cheap paper onto the paper that's going to take the final artwork, you will need a lightbox, which is simply a backlit perspex drawing surface. They are available in all 'A' sizes – I have an A2 which I find adequate. They are expensive, but after the initial outlay you'll have yours for the rest of your life. They are easily sourced online, which is usually much cheaper than an over-the-counter purchase. If you are handy at DIY, they are not difficult to make.

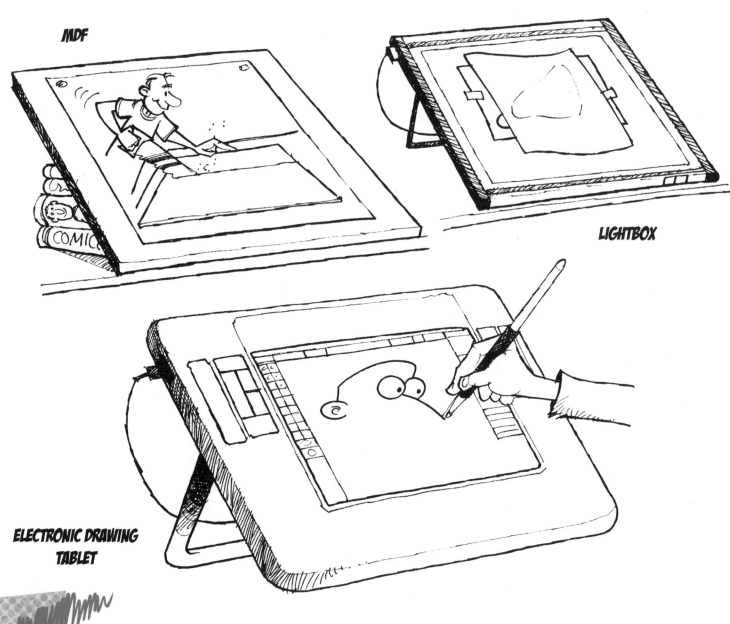

MDF

LIGHTBOX

ELECTRONIC DRAWING
TABLET

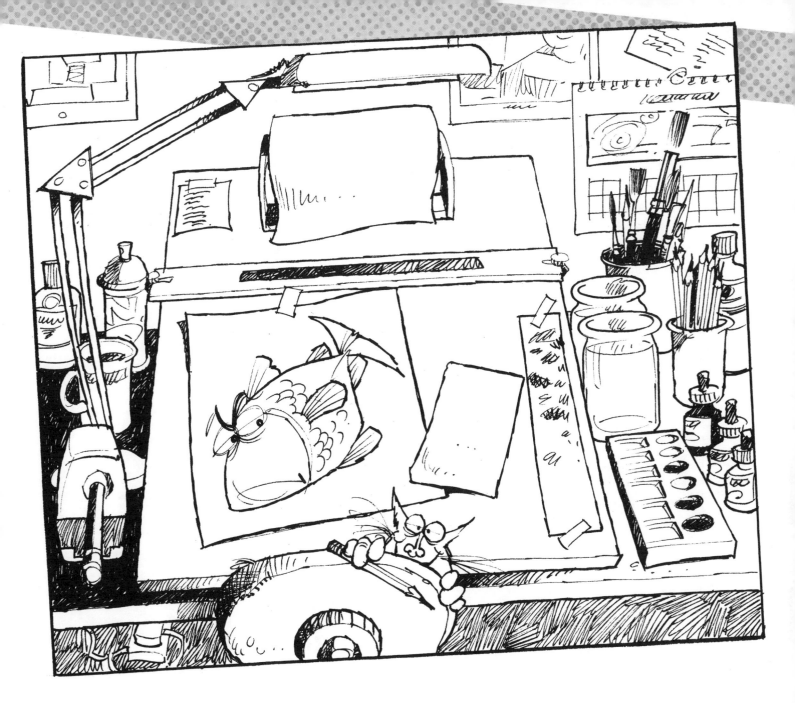

YOUR WORKPLACE

It was once said to me that the way an artist arranges their workplace reflects on the quality of their output, and I think that's largely true. Place your board at an angle that's comfortable – usually about 20 degrees. If you are right-handed, put all your equipment on the right. I keep my pens, pencils and brushes separated in pots so that I can easily put my hand on what I need, and I have two large jars of water to avoid the necessity of interrupting my work to fetch clean water every half-

hour or so. I always have a kitchen roll to hand, and my ultimate luxury is an electric pencil sharpener. A lamp of the anglepoise type positioned directly over the working area is essential.

If you are working from home, try to have an area that is yours alone where you can set everything up and leave it there – if you have to start from scratch each time and keep putting everything away when you've finished it'll deter you from snatching a quick hour's work when an idea strikes you.

BASIC TECHNIQUES

Now you're set up with a workspace and equipment, we'll look at some of the skills that are useful for creating cartoons. The steps towards a finished piece are easy and you can apply them to all cartooning styles.

First, work out your idea on cheap scrap paper. This is where the lightbox first comes in useful; if you want to make an adjustment to a rough, trace the bits you are happy with onto a fresh sheet.

When you are satisfied with your rough, tape it on to the lightbox, using masking tape rather than sticky tape, which can melt onto the glass surface and leave a dirty mark. Place the artwork paper over the rough and trace it through, making further adjustments as you see fit. You now have a pencil drawing of the cartoon.

Having chosen the type of pen you will use to ink in the drawing, put in the black line over the pencil, and when it is dry, carefully clean away all the pencil marks.

If the cartoon is black and white, decide where the blacks are going to fall. I sometimes make a photocopy and black that in first, to see what it'll look like. Then carefully black in the solids. If you want toned areas, equally carefully add the tone. Don't make it too fussy, as it can very easily confuse the viewer's eye; less is better. If you have made a mistake, eliminate it using white acrylic or gouache paint.

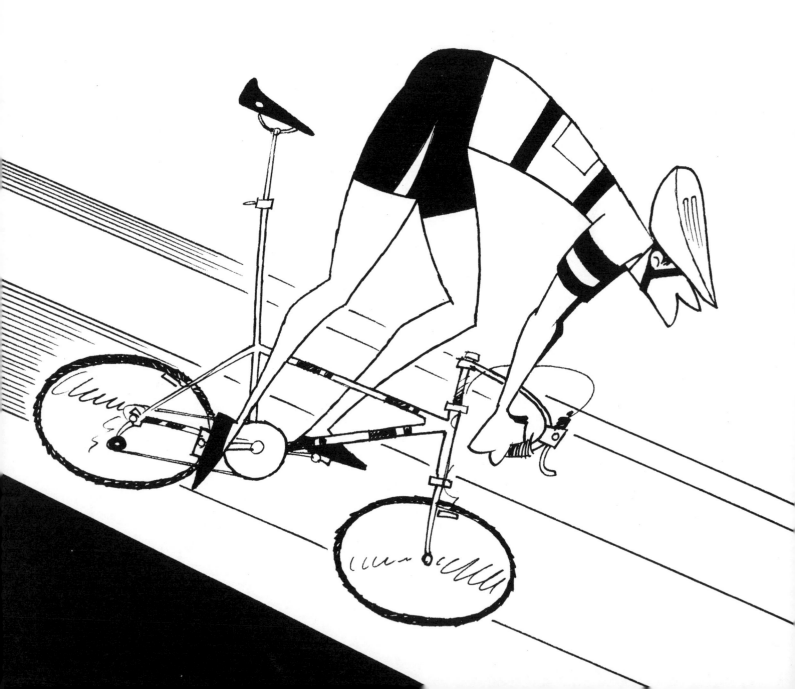

If you find you have a part of the cartoon that is black against black, use a technique called white-lining, again by using white paint. For example, if you want to show a vampire-like figure against a very dark background, paint a fine white line around the figure to make it stand out. If your cartoon is coloured, again black in any areas you feel you want black, then simply colour in the rest of the cartoon.

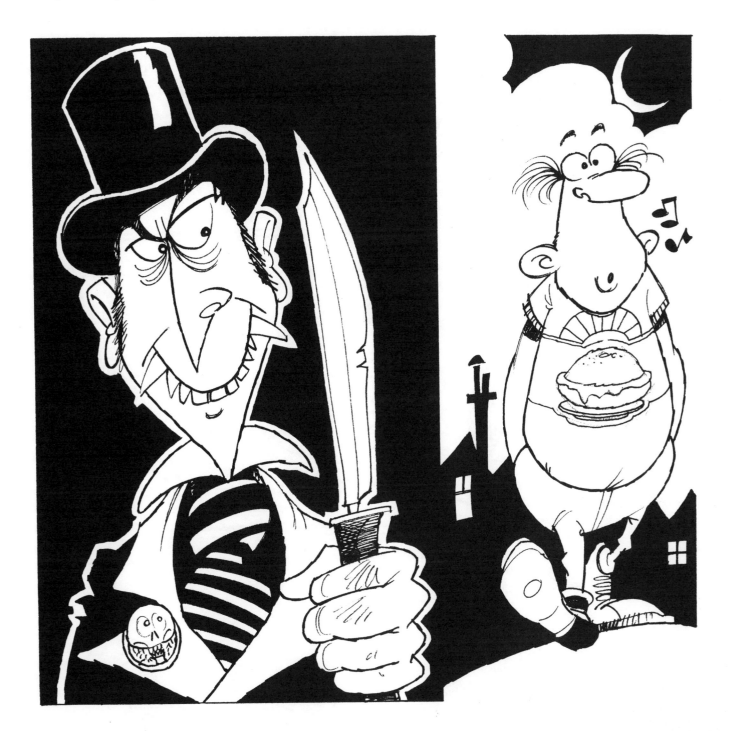

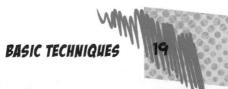

Always pre-mix a range of colours, putting them in the same place in the palette each time. Because watercolour dries quite quickly, you have to work fast, and knowing where the particular colour is makes life a lot easier for you. The worst thing you can do is to start into a big wash area and then run out of colour.

Make sure that you always put the lids back on your colours. Many of them have shellac in them which makes the paint thicken up in a warm environment. They can also oxidize, which turns the colour darker.

Putting blotting paper under the heel of your drawing hand prevents you transferring smudges such as graphite onto the artwork. Have a piece of kitchen roll in your other hand so that you can easily dry your brushes if they get too overloaded. This sounds complicated, but it's very simple, and is very effective in keeping control of your work.

COMIC SITUATIONS AND IDEAS

One question that I am frequently asked is where I get my ideas from. In fact, most of the ideas for the cartoons that I draw are given to me in the form of a brief, which ranges from a casual conversation on the phone to a huge document of many pages filled with detail.

However, unless someone gives you a project, you will have to rely on your own imagination. In this situation, it's best to begin by restricting yourself in what you draw. What are you most interested in? Sport, politics, history, local events or nature, perhaps? Once you have defined your subject, you can then begin to narrow your focus.

For example, you are interested in sport. What kind of sport? Football. Which team? Liverpool. So now you are concentrating on something you probably have a good knowledge of. The next step is to look at what has happened to the team recently, and you discover that Liverpool is about to be sold to an unknown buyer – but it is thought to be a man called Smith who lives in the city.

By this process you have given yourself a brief. The approach you take is up to you, but the secret is to look at the brief as a kind of puzzle. The joke here is in the name of Smith – there must be lots of Smiths in the Liverpool area, which could lead to some confusion. That's your cartoon; an ordinary man who happens to be called Smith being mistaken as the new zillionaire owner of Liverpool Football Club.

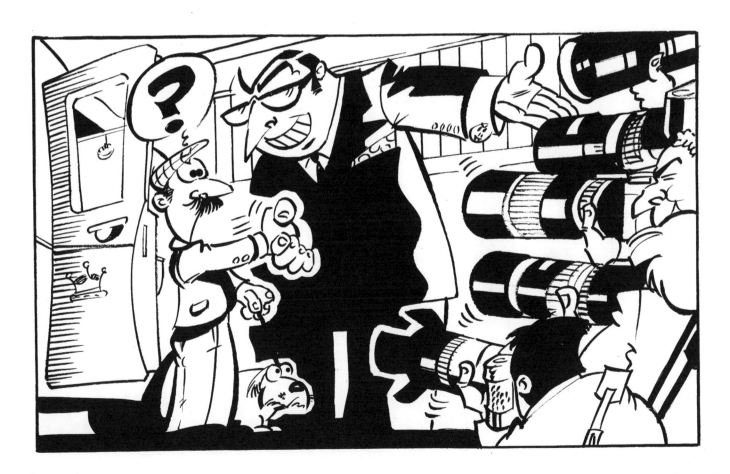

EVERYDAY SUBJECTS

Cartoons are all around us, so it's a good idea to keep a scrap of paper or a little pad in your pocket and jot down what you observe from day to day. This may be your relations at a party or wedding; your pets; your grandchildren; the boyfriends or girlfriends of your kids (it's probably best to steer clear of your own partner as a subject unless you are very sure of a favourable response). And just think of the myriad opportunities in your workplace, where people of many different

personalities are trying to rub along together as a team! You don't have to draw anything in your little pad – just a note of the situation is enough to give you a subject to work up into a cartoon drawing later.

Your drawings don't always have to tell a joke; you can simply take the members of your family and exaggerate their features. For example, you may have an uncle who is rather on the plump side, but his wife is skinny. Do be aware of people's sensitivities, though – what you may see as an affectionate portrait may hurt someone's feelings. For example, while a large nose may be usefully exaggerated to make someone easily recognized in a cartoon, if they have always felt that its size detracts from their attractiveness they won't be at all happy to have it used as their defining feature. People in the public eye are accustomed to

their faults being capitalized on for the purpose of humour, but in a domestic setting the best policy is to draw on strengths rather than dwell on weaknesses.

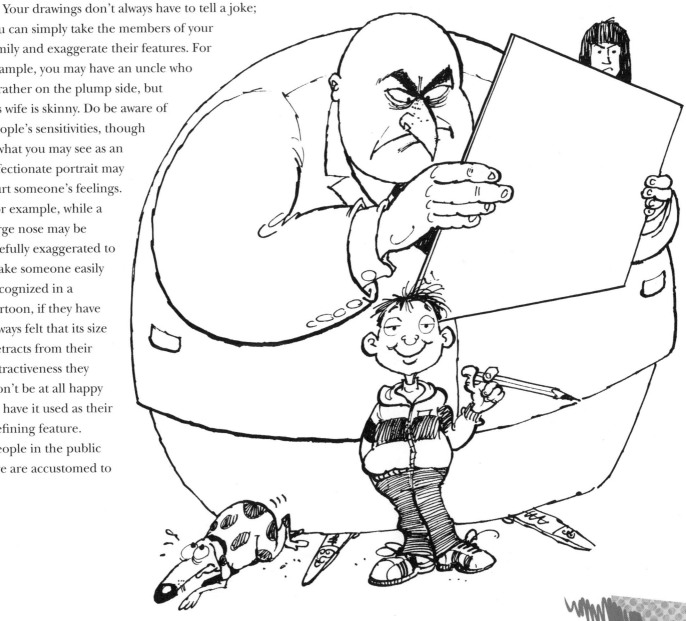

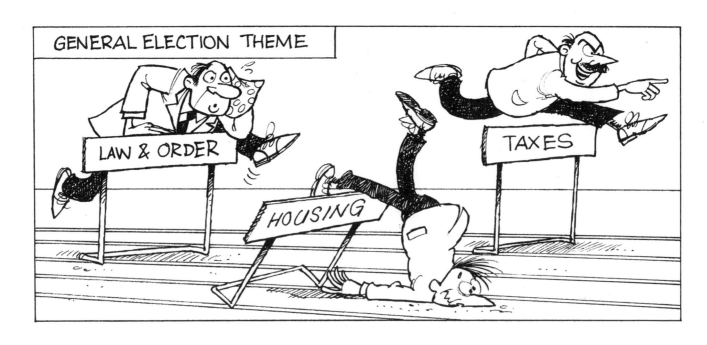

POLITICAL CARTOONS

Some of the best cartoons are concerned with the politicians of the day, a genre that has a long and venerable history. This is an area in which a cartoonist can range from poking fun to expressing incisive criticism and even bitter contempt for a particular figure and his or her actions. The maxim that a picture can say a thousand words is not just a cliché, and it's not unknown for a nervous editor to kill a cartoon that does not in fact contain anything more savage than the text that is allowed through into print.

If you want to draw well-known political figures you will have no difficulty in sourcing many photographs of them from all angles to use as reference. You will also be able to find a range of expressions – and very often the subject will have been caught wearing one that is exaggerated or unflatteringly amusing, which you can then elaborate on. Buy a range of newspapers and study the styles that today's top political cartoonists are using; analysing the particular features of a single figure they have each chosen to highlight will teach you a lot about how to draw someone recognizably but still make your point. Many people in the public eye have very pronounced features – such as a bald head but very heavy eyebrows. Sometimes, a politician's features appear on an animal head to symbolize what the cartoonist feels about the subject: a pig to imply greed, for example, or an attack dog at a time of war.

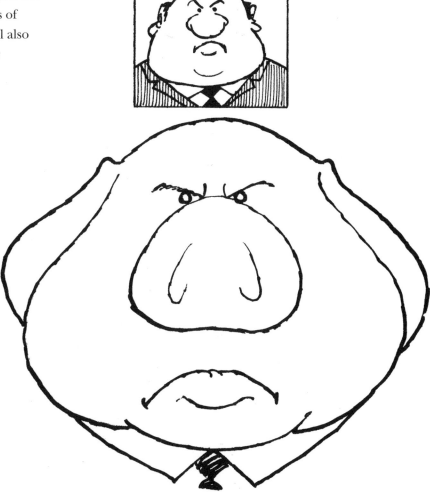

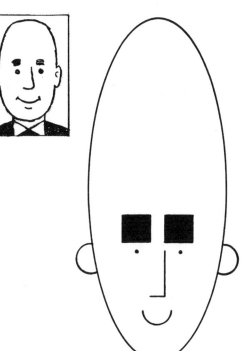

If you feel strongly about a political situation that affects local affairs and you have drawn a cartoon about it that you feel works well, emailing it to your local paper may be the first step towards a career as a professional cartoonist. There is no encouragement to persevere like that of seeing your work in print for the first time. (For more on getting your cartoons published, see page 127.)

CARTOONING THE HEAD AND BODY

Whatever you want to draw, always start your cartoons using the same method. Whether your subject is small, tall, plump, skinny, an alien or a ghost, the preliminary steps always hold good. If you were building a house and tried to skip the foundations you wouldn't get very far! The same applies to drawing cartoons, or indeed anything else.

First, make a basic construction before you start putting in the detail. Failing to do this is a common fault – nearly every novice cartoonist sets off by drawing an outline and hoping for the best. The simple construction method shown here helps you to make a proper start.

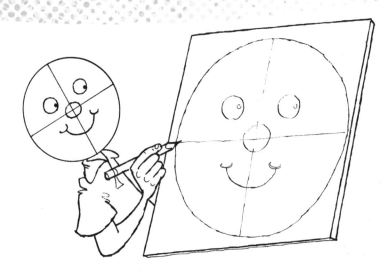

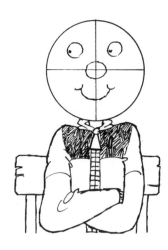

THE HEAD

The head is obviously important because it shows the expression of your character and dictates the type of body you put in. Draw a simple circle with a rough indication of the eyes and nose. This is the basic construction which you should use in all the drawings you make.

Now imagine the kind of face you want and start building it up. Begin with the expression of the eyes and mouth (see pages 36–7) and add hair, wrinkles, warts and so forth later.

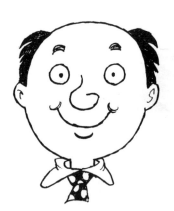

DIFFERENT HEAD SHAPES

Of course not all heads are football-shaped, but fortunately you can adapt the simple construction method to draw all types of cartoon heads.

Different shapes can be used for particular character types, for example a long face for a character who is often grumpy or disapproving, a square one for a macho or dumb character, and so on.

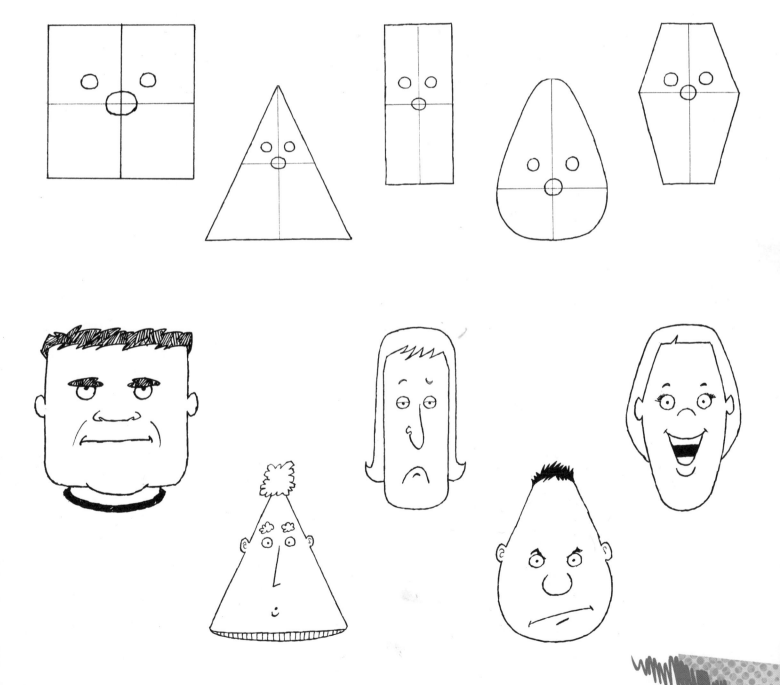

To turn or tilt the head, just go back to the basic construction, but this time move the guidelines depending on which way you want the head to go.

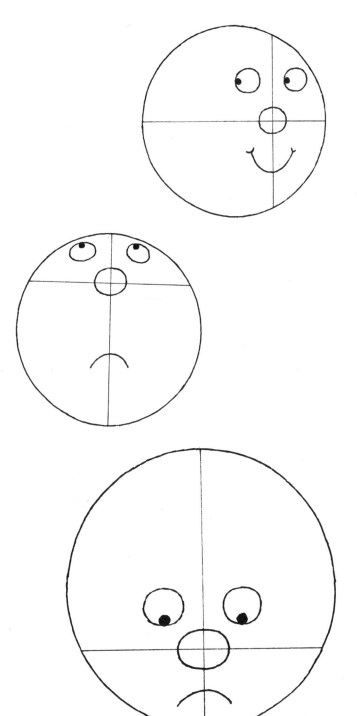

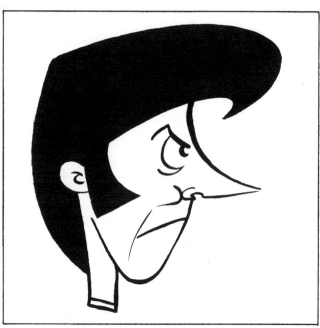

Throughout all this, keep the drawing simple. If you have a lightbox, this is where it comes in useful. When you've drawn the basic face and you want to produce a finished piece of artwork, tape the rough on to the lightbox, put your piece of artwork paper over the top and trace the rough. This is a good time to make small adjustments as you go along.

SYMMETRY

One trick I use to improve the drawing is to turn it over and see if it's symmetrical, since I have a tendency to produce cartoons that lean to the right. Asymmetry isn't necessarily going to spoil what you draw, but sometimes it helps to make the action more balanced. Once you've got the pencil drawing correct, ink it in with whatever medium you have chosen. (To see how to check symmetry using Photoshop, see page 121.)

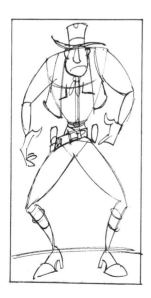
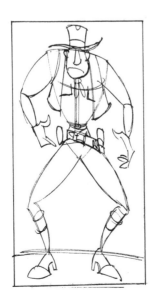
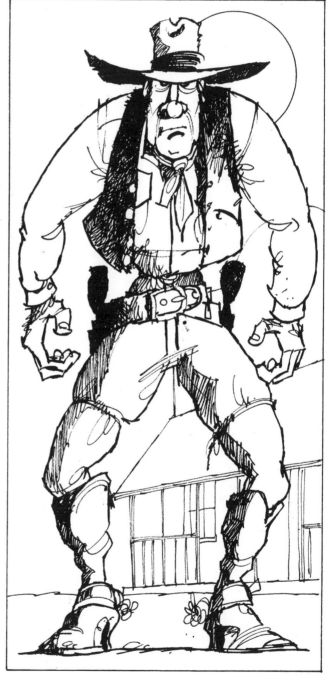

FACIAL EXPRESSIONS

When you come to draw facial expressions, begin with the same basic construction once more. This will give you a good template for just about any type of expression you want to draw.

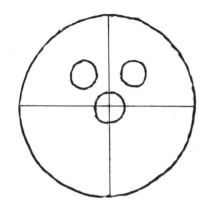 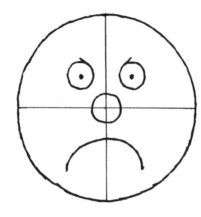 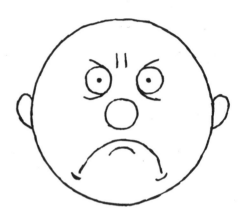

Let's take the example of two contrasting expressions – very angry and very cheerful. Bear in mind the whole time that this is a cartoon you're drawing, so you can be as extreme as you like.

With an angry subject, every feature must show anger – even the hair. Make the eyebrows huge and thick and the eyes tiny, or perhaps put in glasses but no visible eyes at all. For added effect, you could draw steam coming out of his ears. One of the best ways to see what a face looks like with an exaggerated expression is to pull faces in a mirror – but not in public!

With a cheerful face, everything you have drawn before goes into reverse. The eyebrows go up, the eyes are well and truly open, and the mouth grins from ear to ear. Try to make even the hair look cheerful.

The most important point to remember when you're creating these expressions is not to confuse the drawing by putting in too much. Look at the examples here: the expressions have been put in using the minimum of line.

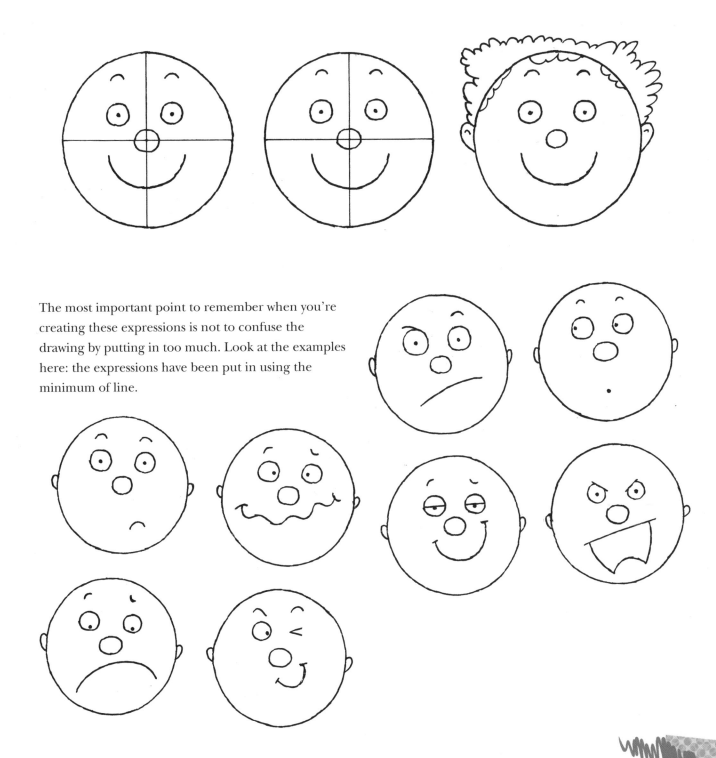

EXPRESSIVE FEATURES: EYES

Eyes are perhaps the most expressive of all the features, and cartoon eyes are no exception. Experiment with eyes of different shapes and pupils of varying sizes, some with eyelids and some without. You'll soon get a feel for eyes that show a particular expression.

 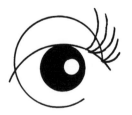

MOUTHS

Cartoon mouths are super-flexible: the same character's mouth can change radically between one frame and the next to show extremes of emotion.

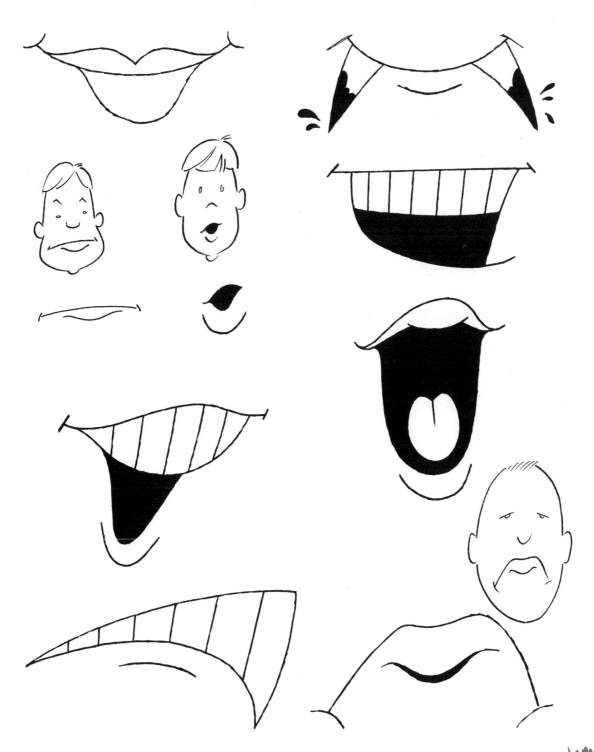

NOSES AND HAIRSTYLES

The shape of the nose will make a big difference to the appearance of your cartoon character, and remember it needs to stay consistent for the character to be recognizable. The same goes for hairstyles, which can be as exaggerated and stylized as you like.

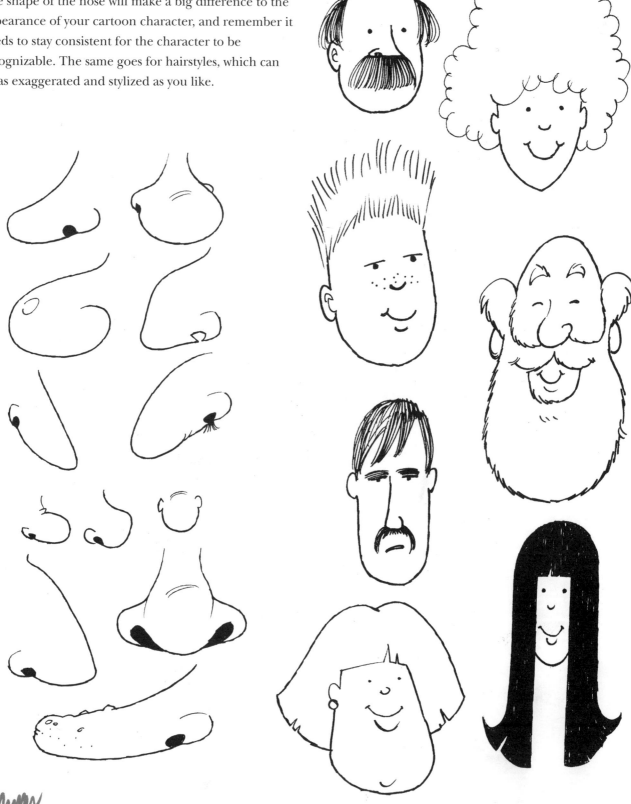

PUTTING IT TOGETHER

Using different head shapes, features, and expressions, the range of characters you can create is – quite literally – endless.

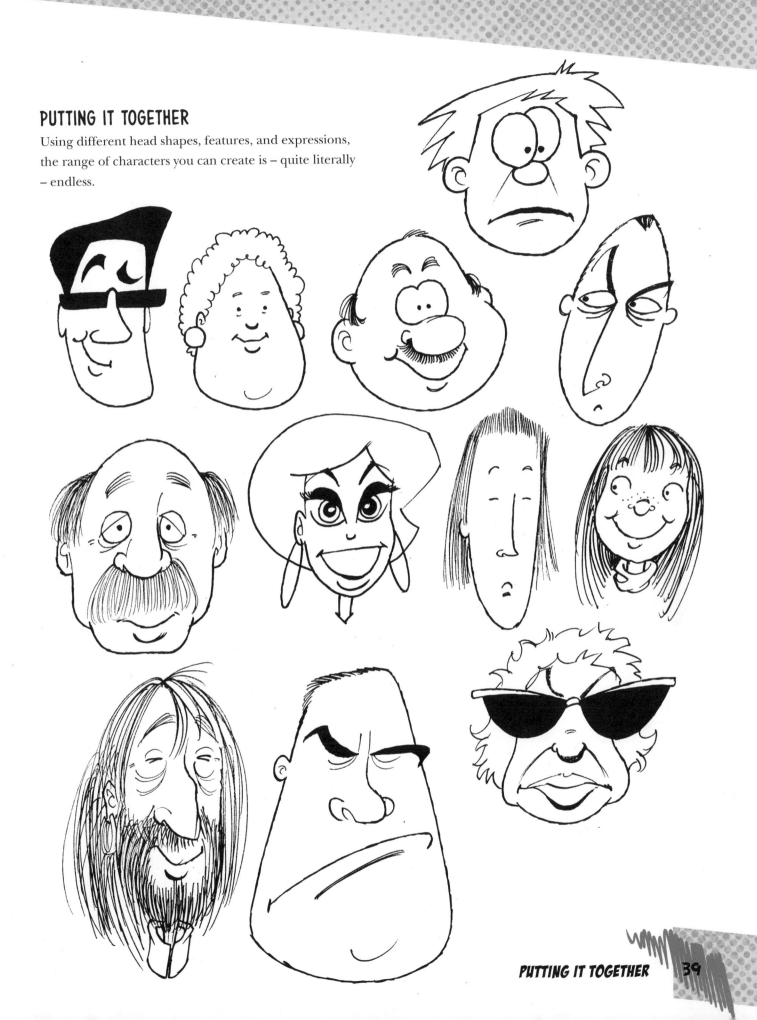

BODIES

The same drawing methods apply to depicting the body as to the head – begin with a basic construction. As you will know, the human body is divided up into sections connected by joints. Luckily, as cartoonists, we don't have to worry too much about all the muscles, bones and other bits and pieces.

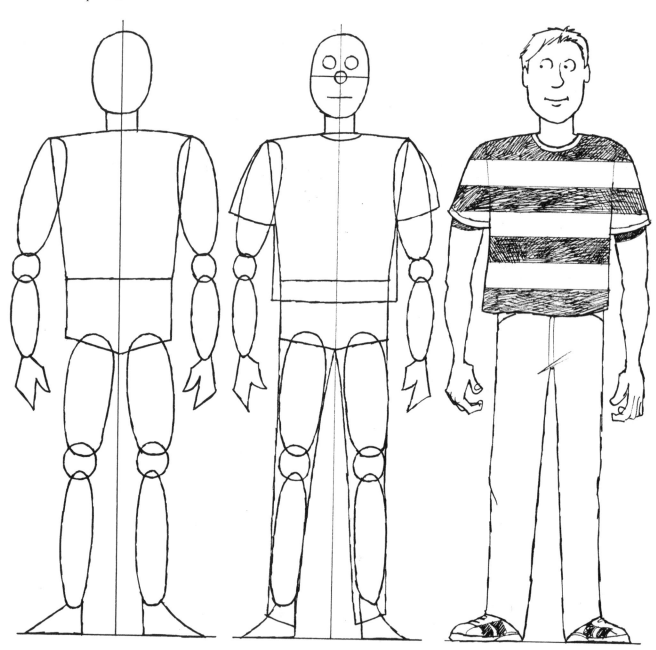

The most important thing about drawing the human body is to get the basic shapes of the torso and limbs correct. We can then distort them to suit the subject matter of the cartoon. Many cartoonists pay only the smallest attention to the details of the body, while others produce very accurate and well-drawn illustrations.

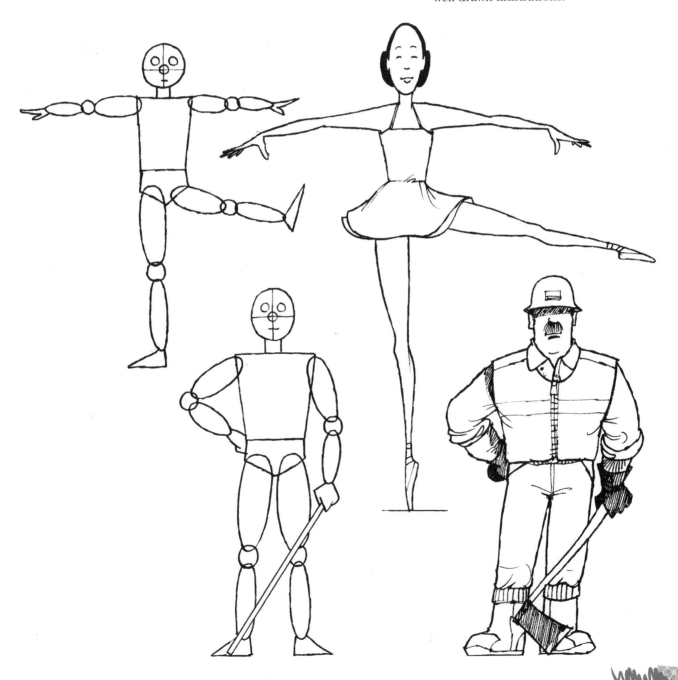

DIFFERENT BODY SHAPES

You can play with the basic construction of torso-limbs-head to create bodies of varying shapes and sizes.

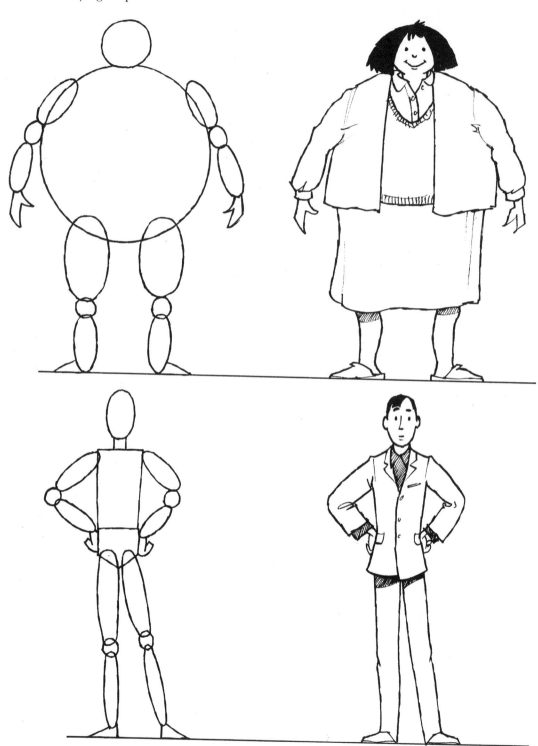

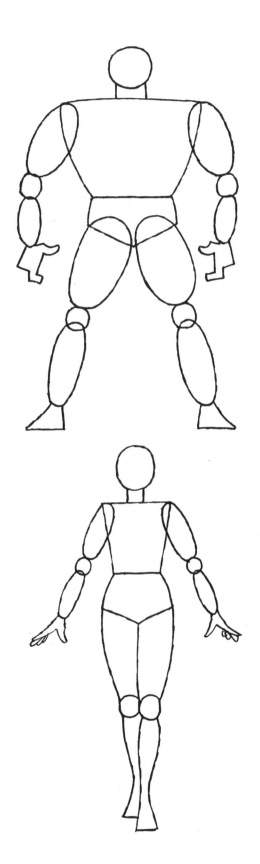

DISTORTION

Although nearly every cartoon that has ever been drawn has contained an element of distortion, its use must be carefully considered since it must coincide with the character of the subject. This also applies to the overall approach to the cartoon. Here is a typical example of both the subjects and the situation they are in being distorted to the maximum.

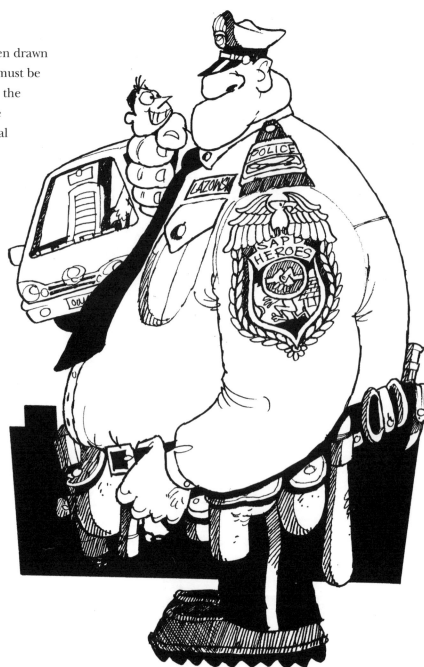

The extent to which you use this approach depends on your own judgement. If the cartoon you are drawing is for a sophisticated publication a less dramatic approach is called for, while if you are drawing for a comic you will need an action-packed, no-holds-barred approach.

HANDS AND FEET

The hands and feet are tricky to draw, but if you approach them with a truly observant eye you should be able to get good results. A big plus is that there is plenty of excellent reference material around, especially when it comes to hands. The simple construction method shown along the top line is very useful for drawing cartoon hands.

1. **2.** **3.** **4.**

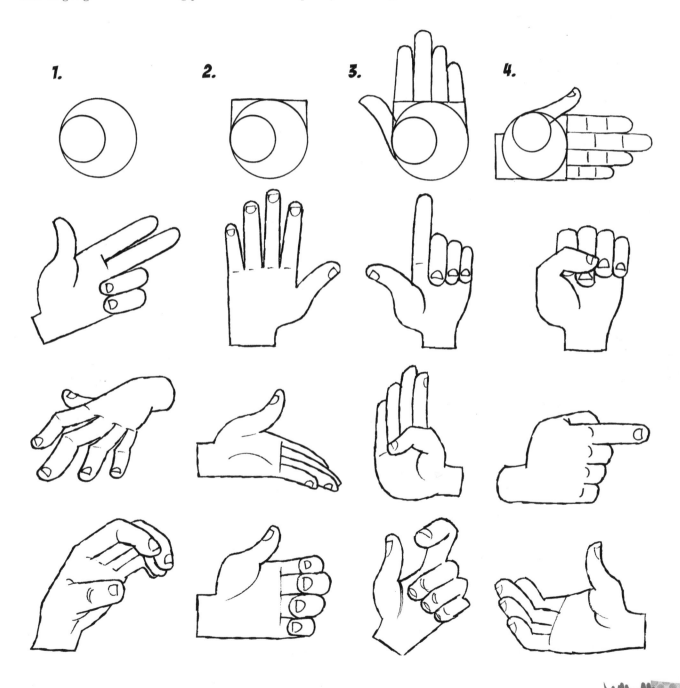

Even feet can be used to add detail and interest to your
cartoon characters. Sketch as many different types as
you can think of.

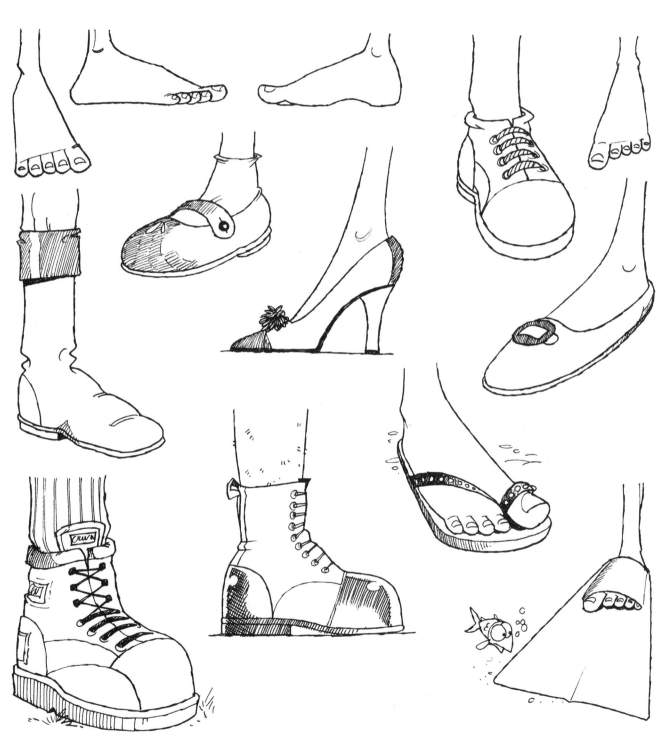

CLOTHING AND PROPS

The temptation here is to draw clothing with the head, arms and legs sticking out – and if you do, that is exactly what it will look like! Instead, rough in the whole body and then add the clothes around it. Whatever type of clothing you choose, make sure that it adds to the message the cartoon is expressing. A large cheerful man who looks as if he's always cracking jokes could be put in a tight suit that he is almost bursting out of, for example, while a severe-looking female teacher will wear rigid-looking, formal clothes. Clothes also emphasize action; a running child dressed in a long coat, hat and scarf will have her hat flying off, the coat billowing out, and her scarf streaming behind her.

The opposite of that is a very old man out walking. His coat, hat and scarf will be hanging straight down, showing that his progress is slow.

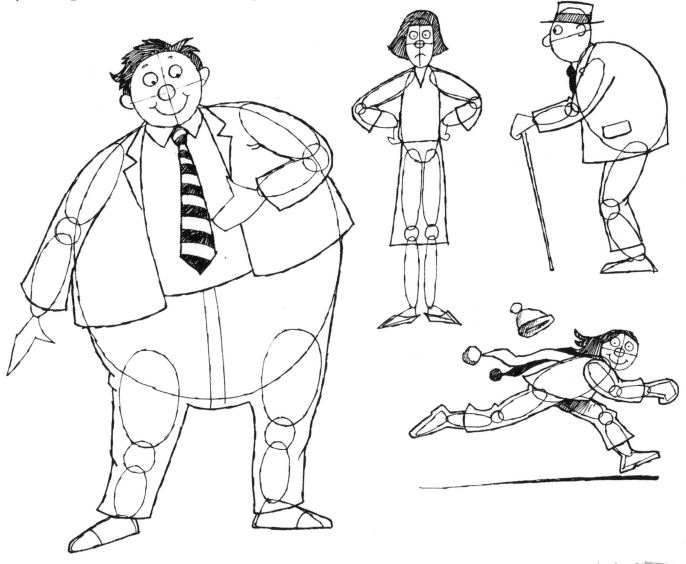

Observation is the key to success with clothing and props. Look at the crowds around you and take in not only the length of dresses and the type of suits, but the little details: an arty woman may wear masses of hefty jewellery, while a young man may have wristbands and piercings. People may be listening to their music on earphones, pushing shopping trolleys, swinging handbags – the list is endless. These individual features are important for building up your characters and giving them authenticity, even though they are cartoons.

Imaginary figures benefit just as much from clothing and props that fit their character and make them instantly recognizable; a black cloak and towering top hat for a vampire for example, or an armoured breastplate for a superhero. This kind of detail is more important in some types of cartoons than others. In editorial material, cartoons tend to be sketchy and relaxed, giving just enough information to get the message across. Cartoons for children can be extremely detailed, as children love to examine drawings closely.

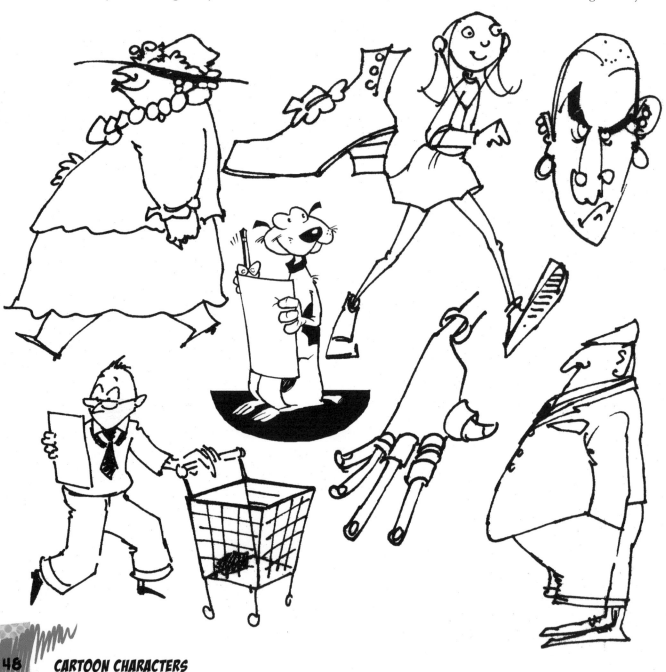

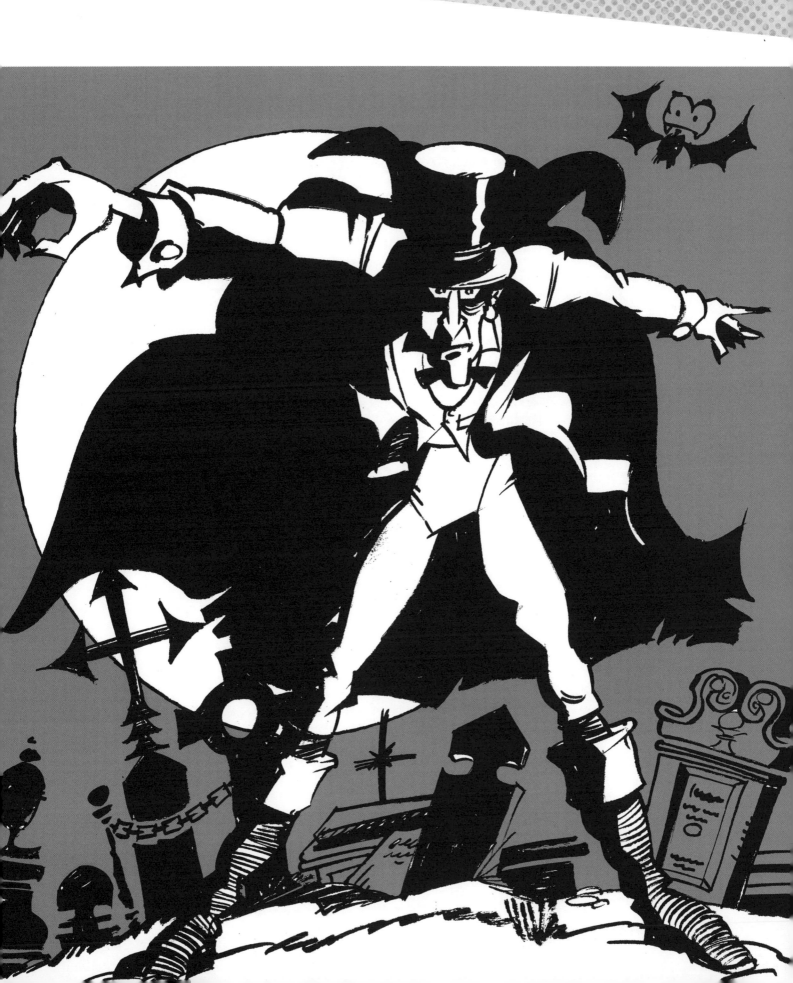

DRAWING FIGURES IN ACTION

You have already learnt how important it is to exaggerate when you're drawing cartoons, and when it comes to showing figures in action you can really go to town.

Drawing action in a cartoon needs to be very carefully planned. The point to remember is that you must always start with the character moving normally – for example, in a running figure, one leg should be forward and the opposite arm back. The body will be leaning forward slightly with the head at the same angle.

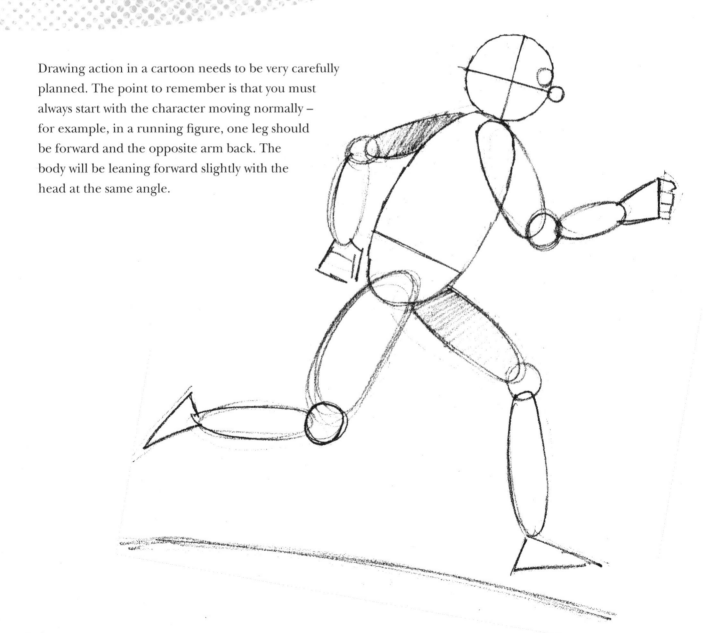

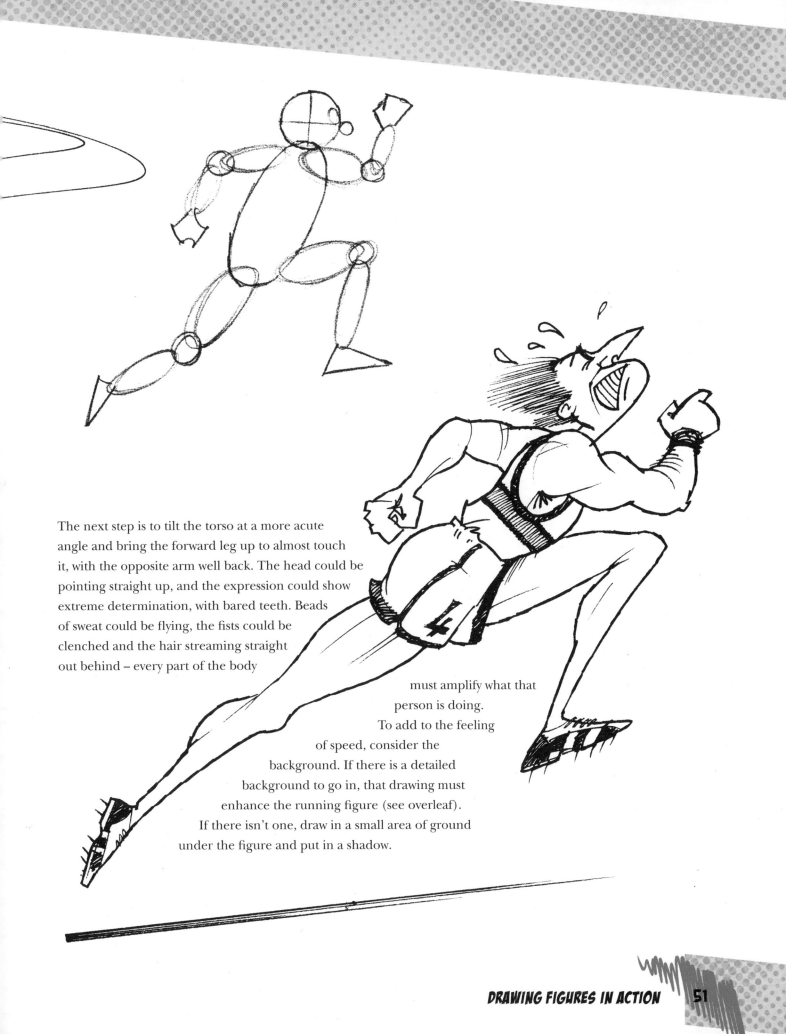

The next step is to tilt the torso at a more acute angle and bring the forward leg up to almost touch it, with the opposite arm well back. The head could be pointing straight up, and the expression could show extreme determination, with bared teeth. Beads of sweat could be flying, the fists could be clenched and the hair streaming straight out behind – every part of the body must amplify what that person is doing. To add to the feeling of speed, consider the background. If there is a detailed background to go in, that drawing must enhance the running figure (see overleaf). If there isn't one, draw in a small area of ground under the figure and put in a shadow.

If the figure you're drawing is running round a track, one approach is to draw all the stands and buildings that surround it leaning in the opposite direction to that of the runner. If there are people in the background, they could have surprised expressions, with their hats flying off. Cars could be leaning back, birds could be thrown off course – you could even make the clouds lean back.

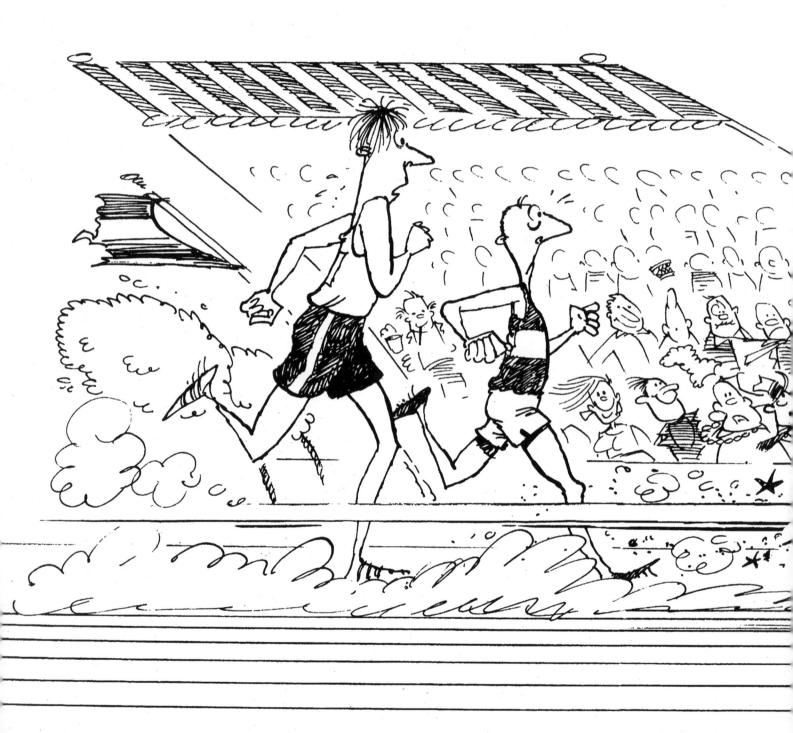

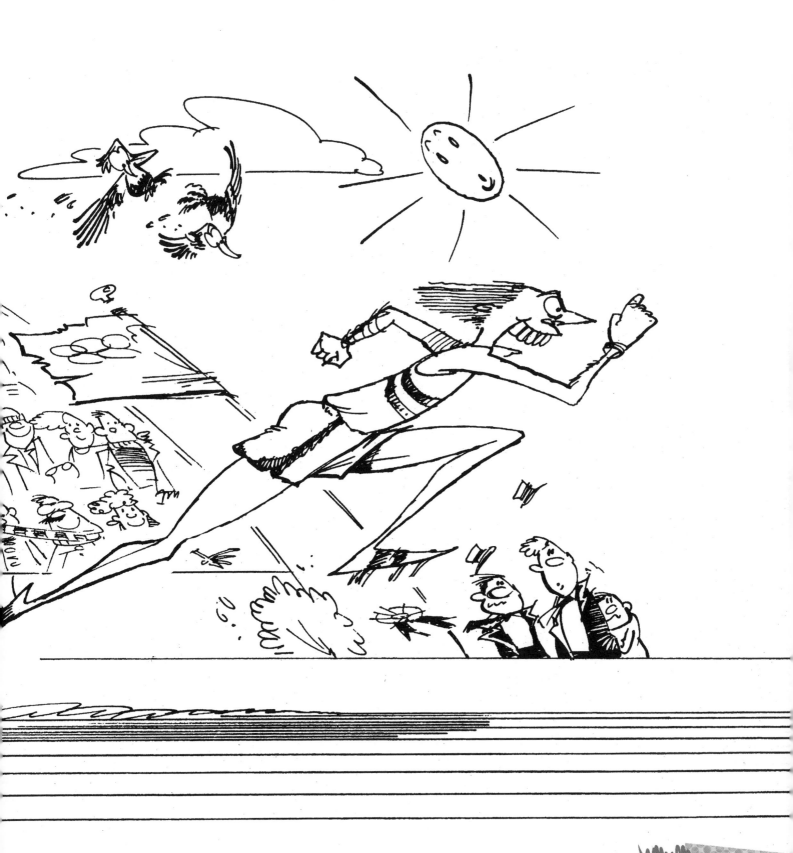

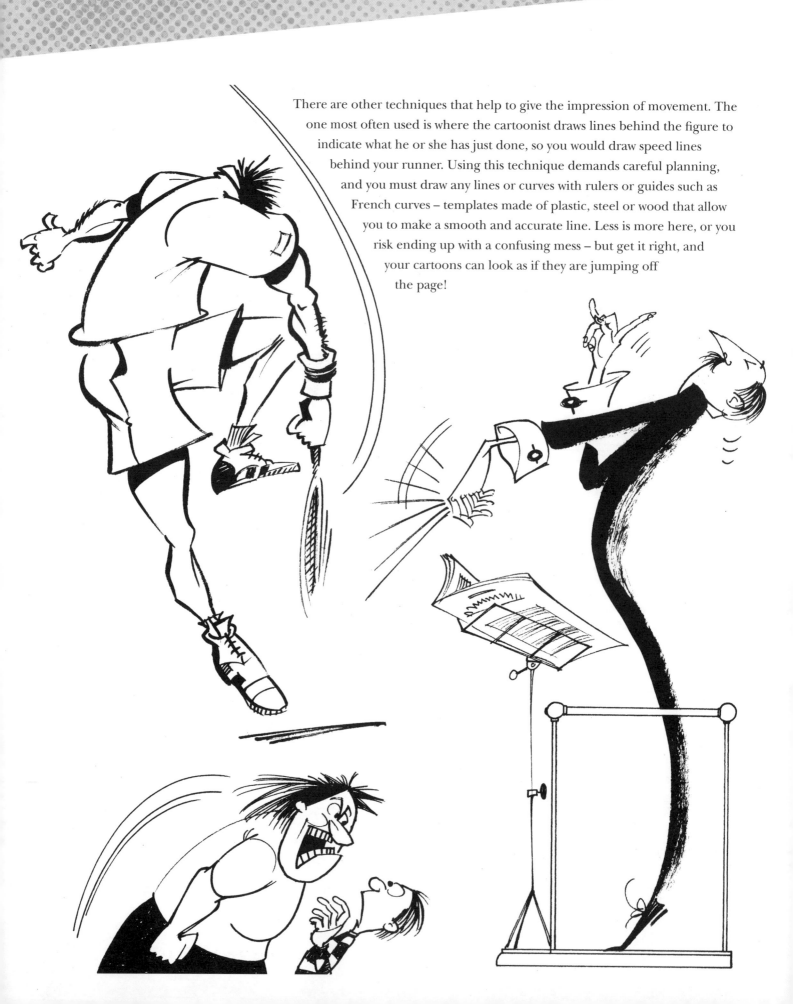

There are other techniques that help to give the impression of movement. The one most often used is where the cartoonist draws lines behind the figure to indicate what he or she has just done, so you would draw speed lines behind your runner. Using this technique demands careful planning, and you must draw any lines or curves with rulers or guides such as French curves – templates made of plastic, steel or wood that allow you to make a smooth and accurate line. Less is more here, or you risk ending up with a confusing mess – but get it right, and your cartoons can look as if they are jumping off the page!

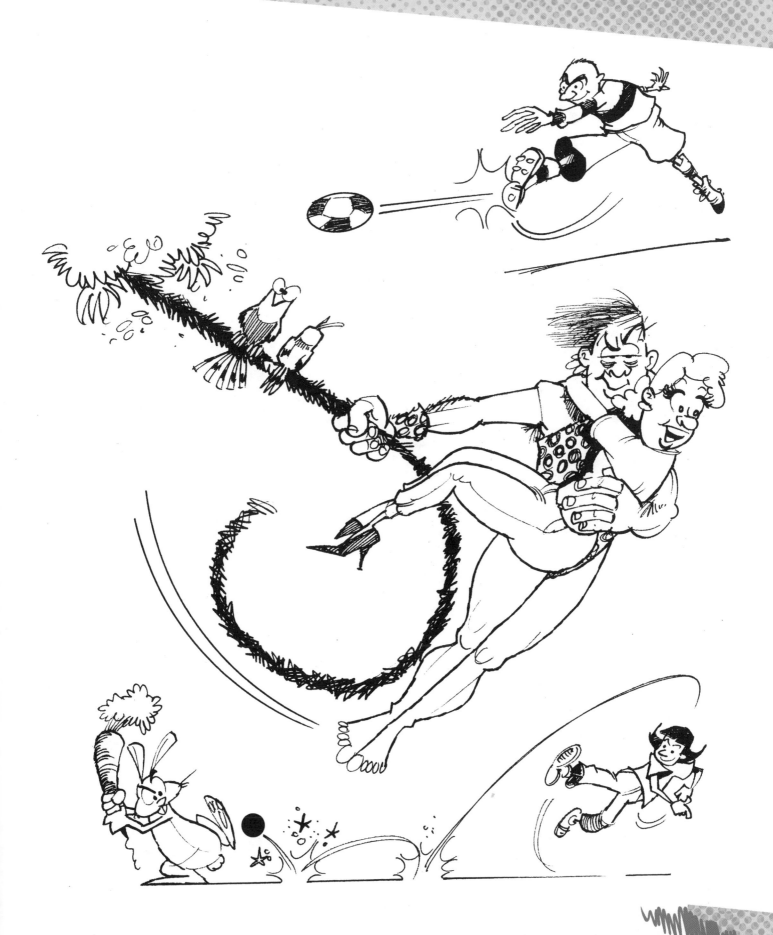

CARTOON ANIMALS

The main difference between cartooning animals and humans is that whereas we humans share the same bodily characteristics, animals do not – there are so many mammals, fishes, birds and insects it may seem difficult to know where to begin. In fact, the same construction methods that we used for cartooning the human head and body apply to drawing animals too.

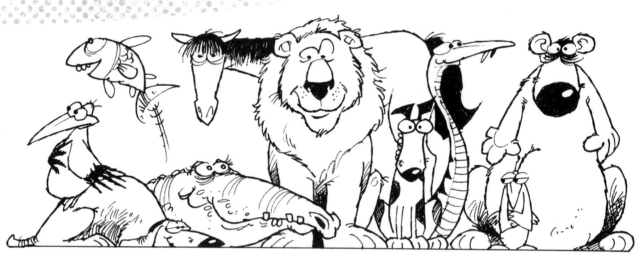

ANIMAL HEADS

The secret of drawing animal heads is to take the simple approach of deciding that the only real difference between a human being and an animal is in the nose. This of course isn't true, but it fits our purposes very well. Because most cartoon animals are portrayed doing something human, or having an expression that is human, they must therefore retain as many human characteristics as possible.

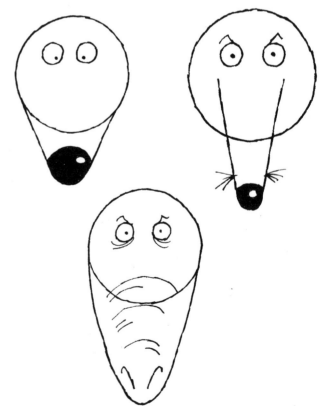

Draw in the basic characteristics of your animal simply and clearly so that the viewer can immediately recognize what species it is. Once this has been done, the cartoon element kicks in.

The eyes and expressions can both be human. Expressions on animals are quite easy to draw, because they have characteristics such as long hair, big teeth and whiskers that help the expression along.

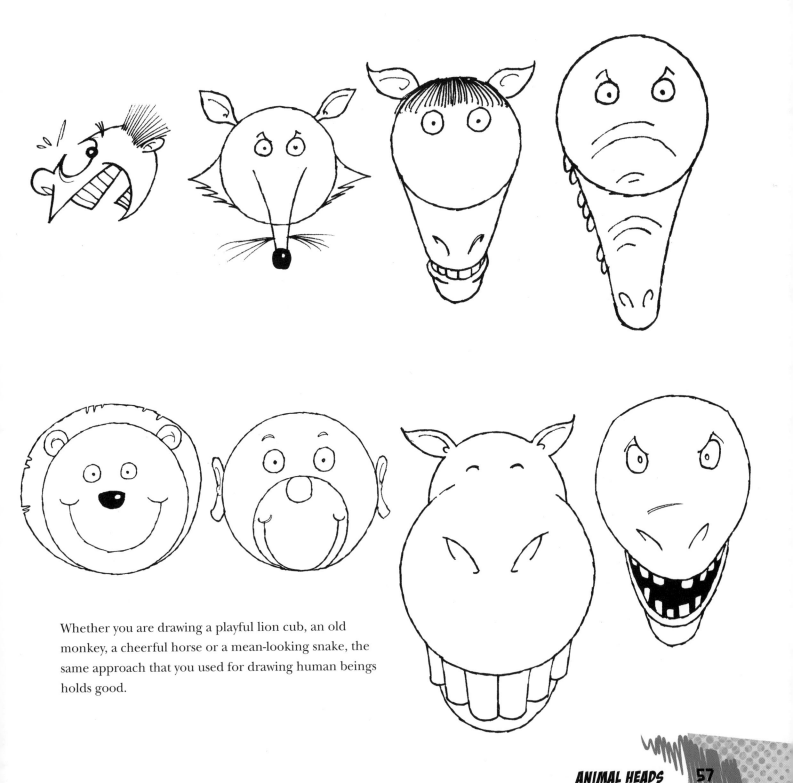

Whether you are drawing a playful lion cub, an old monkey, a cheerful horse or a mean-looking snake, the same approach that you used for drawing human beings holds good.

Animals have very defined features for you to make
use of. One characteristic of horses is that they have
extremely large teeth, so if you are drawing a horse
laughing, exaggerate them and make them huge. Cats
have tails and long whiskers, so use them to their
fullest effect.

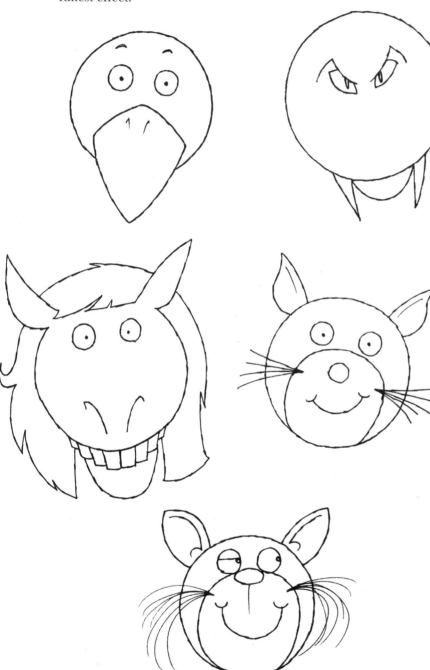

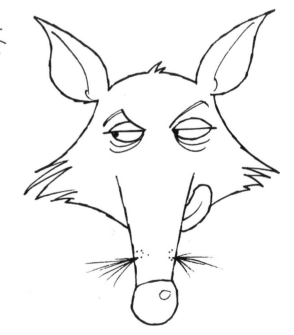

ANIMAL BODIES

The secret of drawing animals is to decide that there is very little difference between their bodies and those of human beings. Where the main difference comes is in the proportions. Some bodies are much longer, some much shorter. Some of the 'arms' and 'legs' are extremely long, some tiny.

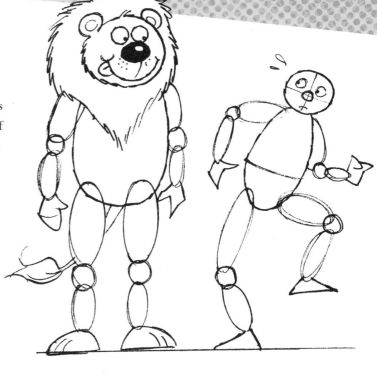

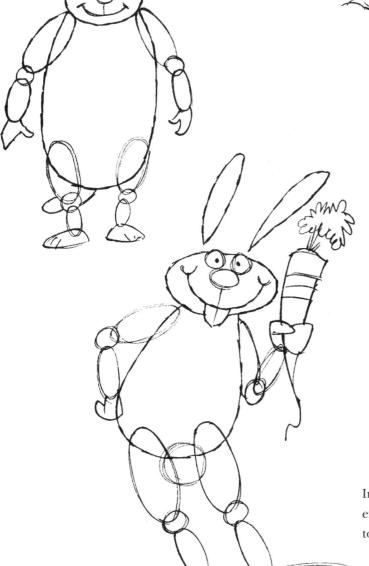

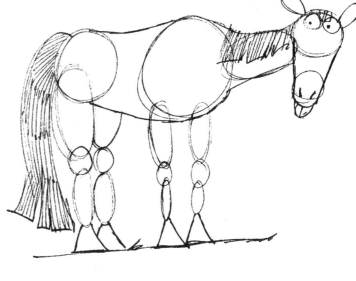

In the world of cartoons, animals can behave and move exactly as humans do, and share the same emotions, too. Some, of course, cannot be made to stand upright – a giraffe or a horse, for example. Here you have to rely to a greater extent on the expressions on their faces.

Taking three very different animals, a bird, a horse and bear, construct the bodies using circles and simple shapes. When you feel everything is in position, you can rub out your guidelines and add some detail.

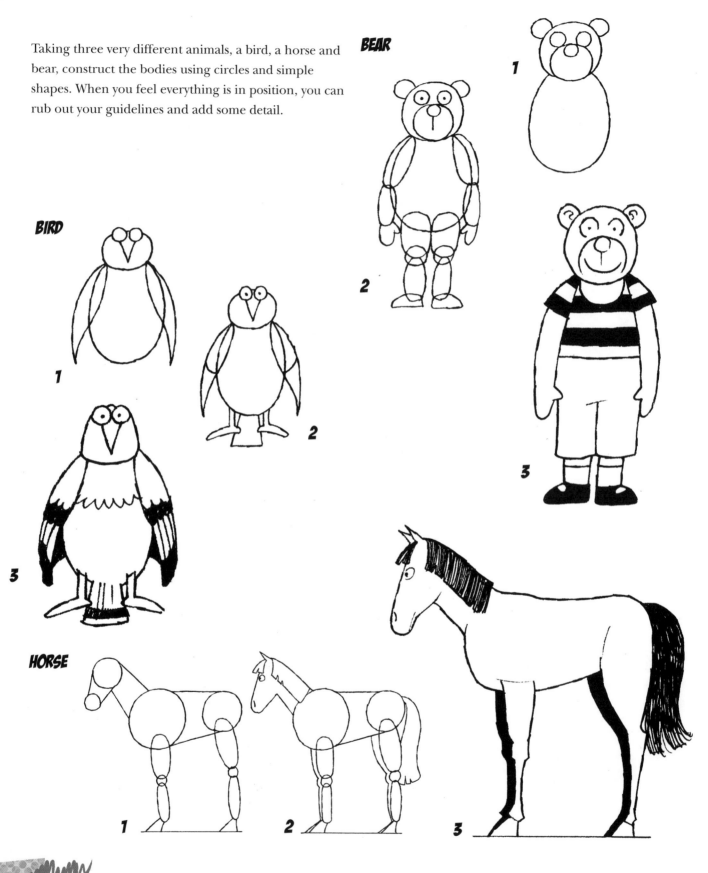

BEAR

1

2

3

BIRD

1

2

3

HORSE

1

2

3

An important and very enjoyable aspect to drawing animals is that you can distort them in any way you want provided you retain the basic characteristics of that species. Alternatively, you can even make up your own animal and invent a whole new species! Here you can let your imagination run free.

As you will know, there is a long tradition of drawing 'human' animals. I often think that these drawings are a great deal more expressive than similar drawings of human beings.

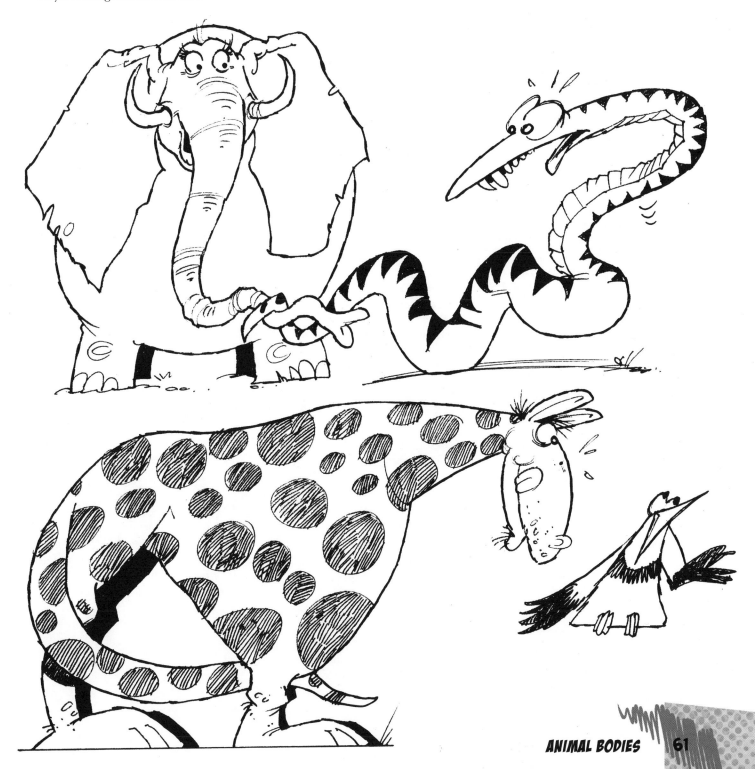

ANIMAL PROPS AND CLOTHING

If you are going to put clothes on animals, use the same approach as for humans, adding the clothes after you have drawn the body. The clothes you choose will of course depend on the animal you are drawing – a lion in top hat and striped trousers, a giraffe in just a collar and tie, a monkey in a T-shirt, a penguin wearing a rubber ring, an elephant with a wrist watch on its trunk and so on. Detail is even more important here because it helps to heighten the absurdity of your drawing.

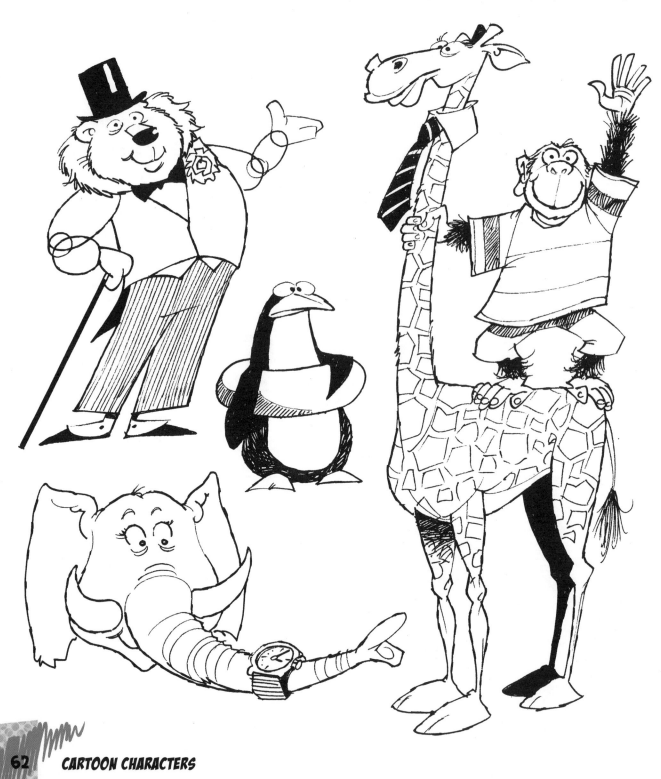

Think about the behaviour of an animal, then heighten the effect. For example, squirrels move incredibly quickly, so give them skateboards to help them go even faster.

In the examples below, I dressed the animals in clothes that their human counterparts – grumpy teenager, elegant old lady, country gent – would be wearing.

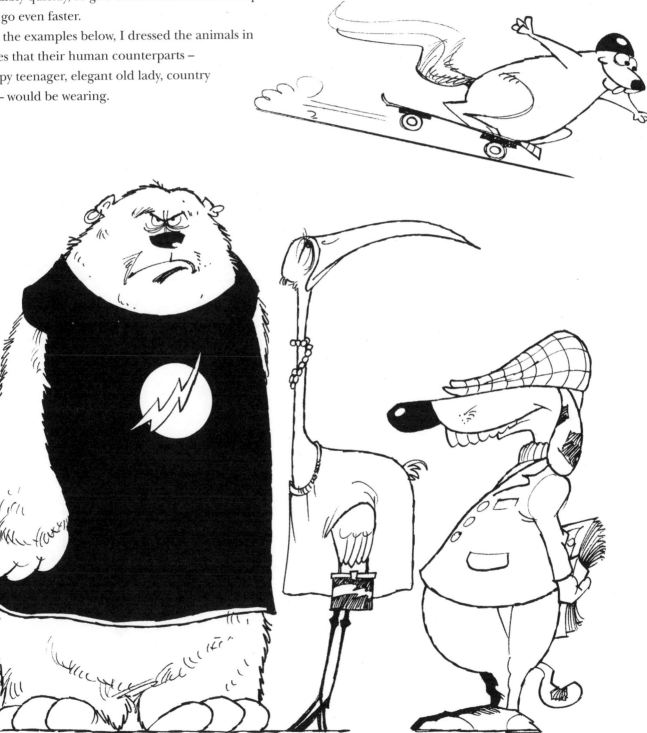

THE ELEMENTS OF YOUR CARTOON

CARTOON OBJECTS

So far in this book, we have discussed cartoon figures and their counterparts in the animal world. But in a cartoon picture, every object is a cartoon and must be drawn as such.

There are many examples of what I mean, but let's just take one situation – a chase, which is pretty much standard cartoon fare!

A man is chasing a dog who has just driven off in the man's car. The man is on a bicycle, and he has ridden under a ladder on top of which is another man trying to clean windows. So we have a car, a bicycle, a ladder and a bucket full of water. These are everyday objects that aren't comical in themselves, but we have to make them look funny.

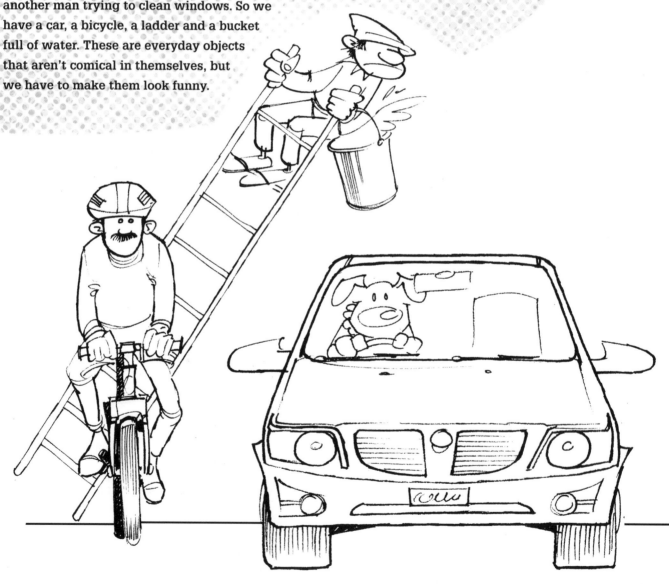

One of the easiest ways to add humour is is to use distortion. Let's take the example of the ladder. Boring! A ladder doesn't bend. So we bend it and lose a few rungs. Have you ever seen a bike tearing along in mid-air with the wheels going round so fast the front one has left the bike behind? It's absurd, but this is a cartoon world we're in and anything goes. But plan your drawing carefully. It has to be close enough to reality to look feasible.

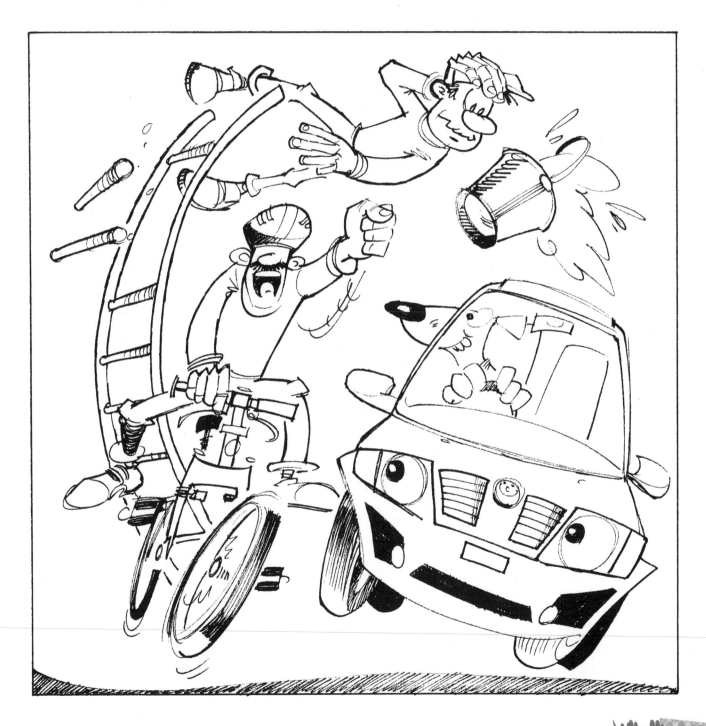

Inanimate objects can also be given human
characteristics such as faces, arms and legs. They don't
all lend themselves to this approach, but try it. A simple
test here is to draw them moving. If you can do that
without too much trouble, you've drawn a winner!

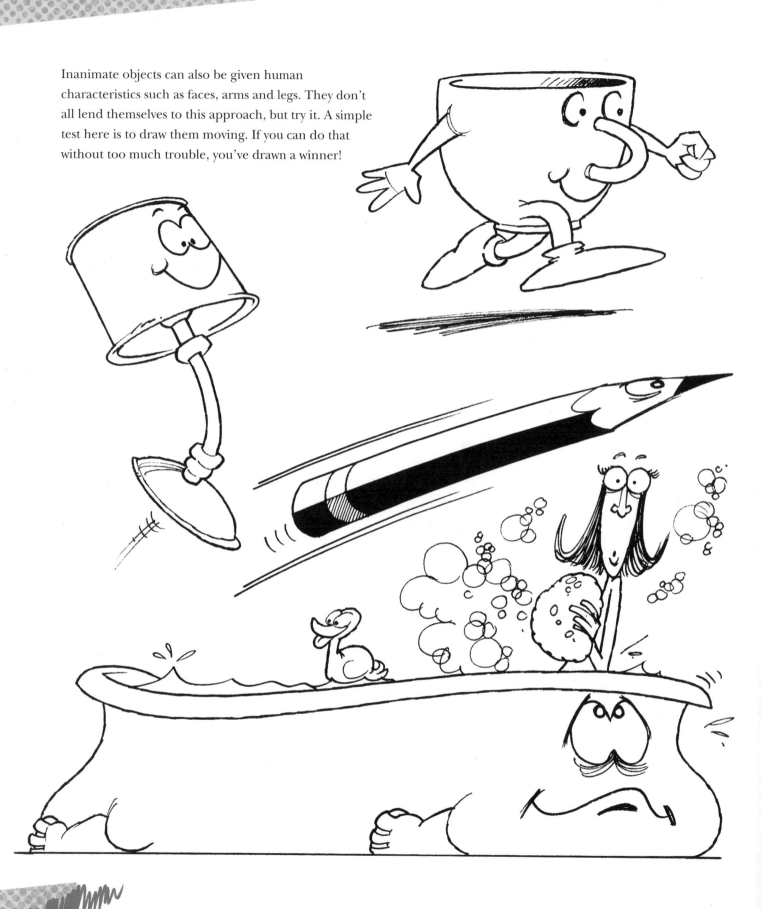

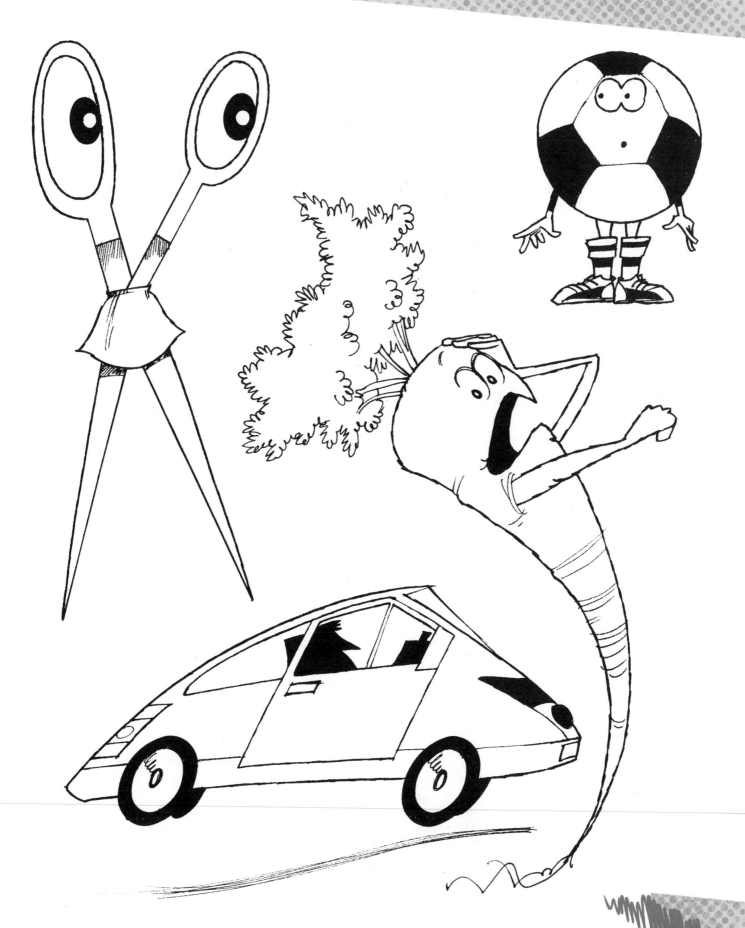

LAYOUT

Layout is all about presenting your artwork in the most exciting way you can think of. It applies not only to the arrangement of elements within an image, but also to the way the image is framed, and the way it is placed in relation to other images or captions on the page. Cartoons have to send a message to the reader, so it's up to the cartoonist to use whatever methods are available to get that message across. This means understanding the rules and applying them, but also breaking them to achieve the effects you want.

The first thing to do is to establish exactly what it is you have to draw. For example, let's say you want to show a mythical hero, facing danger from a monster that's climbing from a pool of blood!

You must decide the most exciting way to show this situation. Make a quick drawing of both figures, just to get something on paper. To decide on the best viewpoint, imagine you are a cameraman, looking for the best angle to point his camera.

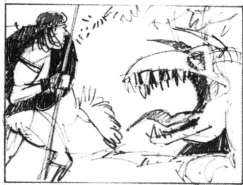

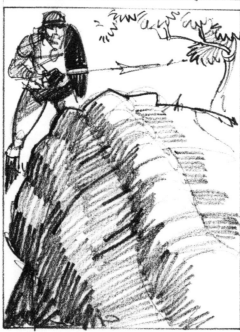

If the drawing is to be part of a strip, then think of the whole sequence. The hero is facing danger from a monster, and there's going to be a fight in which someone will be killed.

Changing the viewpoint in each frame and using close-ups will help to make your strip look dynamic.

An important point to remember is to show the maximum of action to grab the reader's attention. However, try not to put so much into the artwork that it becomes confusing to look at.

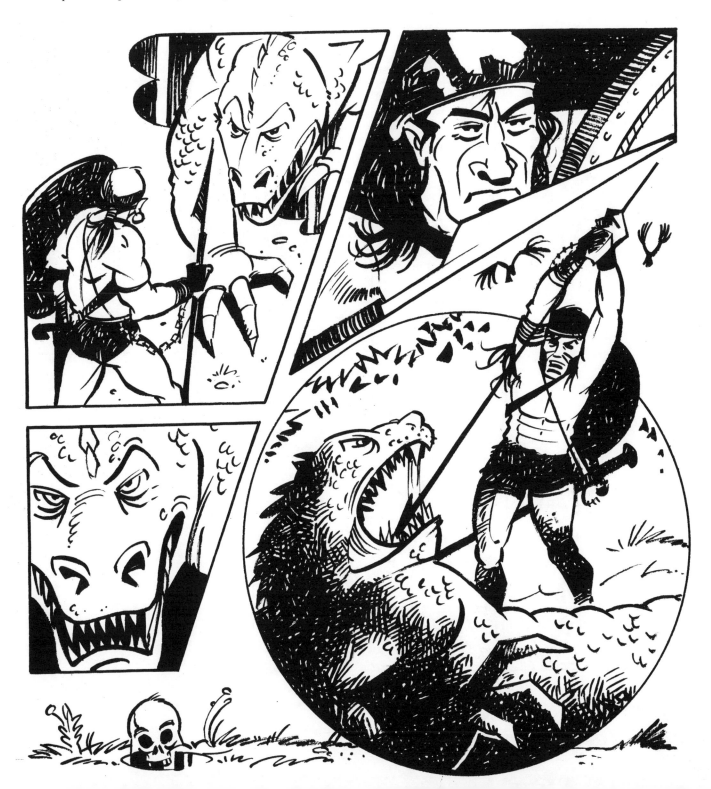

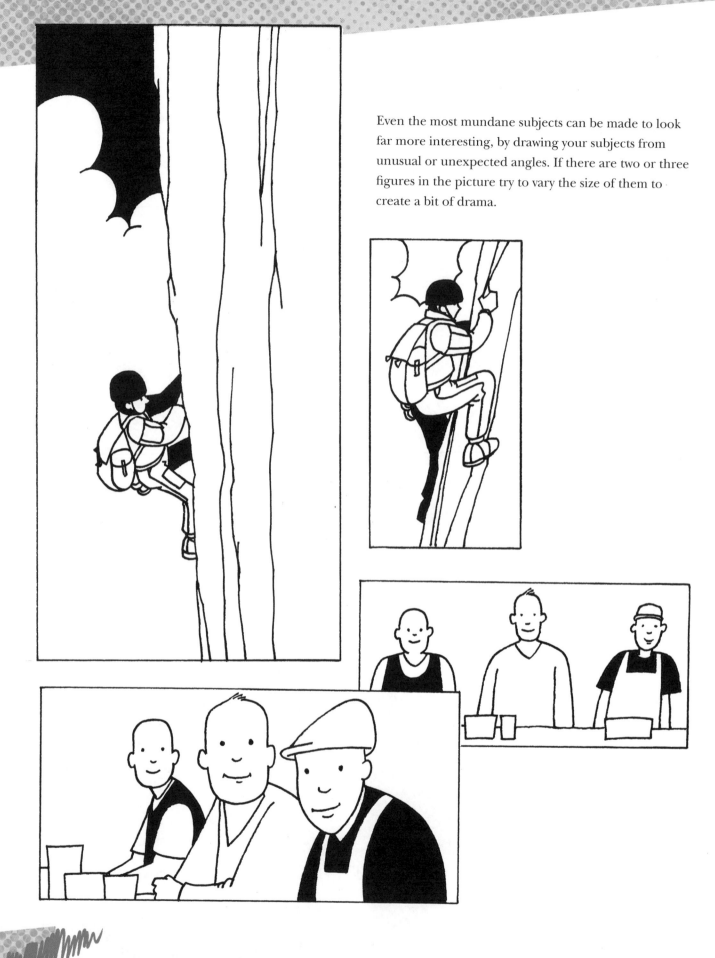

Even the most mundane subjects can be made to look far more interesting, by drawing your subjects from unusual or unexpected angles. If there are two or three figures in the picture try to vary the size of them to create a bit of drama.

BACKGROUNDS

Backgrounds play a very important role in setting the scene in a cartoon. In fact, background artwork is sometimes drawn by different artists using other techniques to that of the character artist. There are some wonderful examples of this art, for an art it certainly is.

Cartoon figures can be drawn without any dramatic lighting or clothing but can be utterly transformed by placing them in a sinister background, for example. The background sets the scene, particularly in animated films.

In the cartoons we are drawing, this level of detail isn't used as much, unless there is a particular reason for it, and usually only one artist will draw the entire cartoon. A great many cartoons will only require enough drawing to indicate where the action is taking place.

I use what I call a system of 'drawing shorthand'. To place your drawing in context, you only need a cloud, a bit of grass or a tree to show that the character is in the open. If you're drawing a figure indoors, a part of a chair or door or a pot plant on a table is enough to settle the figures in their correct context. You will have to use your own judgement regarding how much you draw – you don't want to swamp the foreground if it's not necessary.

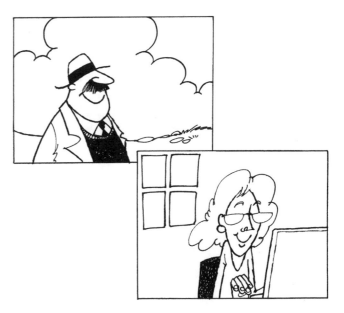

Some cartoons will need a very detailed background. If the setting is a recognizable one, such as a supermarket, it's best to get good reference material to draw from. The style of drawing you choose is your decision – it can be drawn in the same style as the foreground figure or it can be totally different, even using a different medium. You will need to take as much care with this type of background as you do with the foreground.

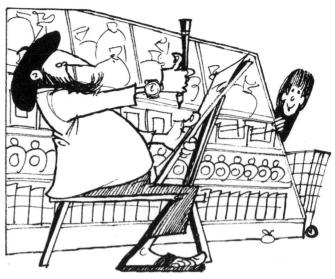

THE ELEMENTS OF YOUR CARTOON

Whatever is called for in the background, the approach you take is up to your own judgement. If the setting is a street scene, but has no importance other than that of being a location, then draw it simply, letting the foreground dominate. If, however, the street scene is an important part of the story you are telling, you may draw a very detailed rendition of the street, and have the figures of secondary importance, letting the background dominate.

No matter how you decide to treat them, the two parts of the cartoon illustration – foreground and background – must work as one composition.

SECONDARY BACKGROUND ACTION

So far we have only talked about inanimate backgrounds where there is no interaction between the foreground figures and the background. But in many cartoons, particularly in animated films, there is often a whole extra scenario going on in the background that runs parallel to the main action. I call this a secondary level of humour. It can work as a part of the main action, or go off on its own. This particular aspect of cartooning is a great favourite of mine.

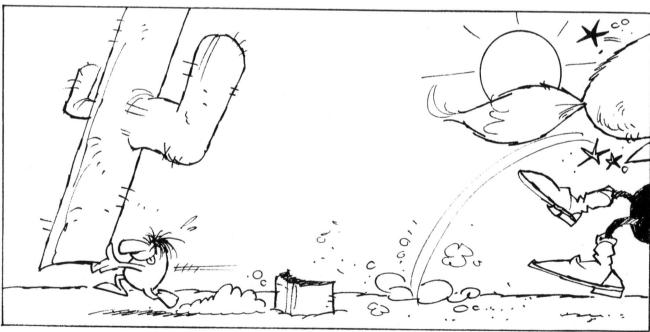

THE ELEMENTS OF YOUR CARTOON

This technique really only works where there is more than one drawing. In a single-frame cartoon there's never enough mileage for the reader to understand that the strange objects scuttling around in the background make up this secondary level. In a book or a strip, it's much easier to achieve, and in some cases these secondary figures have become stars in their own right, such as Calvin's parents in the cartoon *Calvin and Hobbes*.

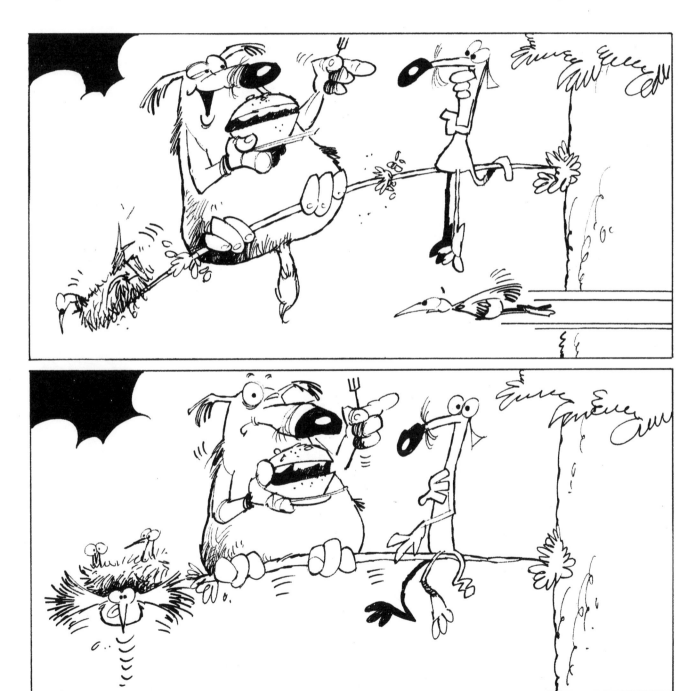

THE 'P' WORD

Perspective is a subject that people tend to shy away from like a frightened horse. There is a feeling that it is mysterious and difficult to master, but in fact it can be as simple or as complicated as you want it to be. I have heard many people say, 'I don't do perspective.' In some extreme cases, people give up trying to paint or draw altogether rather than tackle it. This attitude is nonsense! There is perspective all around us. We see it every single moment of every single day of our lives. Without perspective, the world as we view it would be a very curious place indeed.

The basic idea behind perspective is that if a car or indeed any other object is big it's close, and if that same object is small it's further away. I think drawing that is not beyond most people's capabilities. And if you do draw it, then you've drawn perspective!

If you can draw perspective, you can skip the next bit. However, if you have struggled with it, I hope this will help.

There are three basic kinds of perspective: one-point, two-point and three-point. For 'point' read 'vanishing point'.

ONE-POINT PERSPECTIVE

Draw a line across your piece of paper: this is called
your horizon line. Make a single point on the line (your
vanishing point) and draw two diagonal lines of the
same length out from this point. Join up these two lines
with another horizontal. Draw two more lines outward
from the vanishing point, and connect them to the
existing lines by drawing verticals. Now you have a cube
shown in one-point perspective.

TWO-POINT PERSPECTIVE

Draw a horizon line and mark two vanishing points at
each end of it. Between the two points, draw a vertical line
cutting through the horizon line. Then join the ends of
this line up with the vanishing points. Add two more
vertical lines on each side of your first one and you have a
cube seen from the corner, in two-point perspsective.

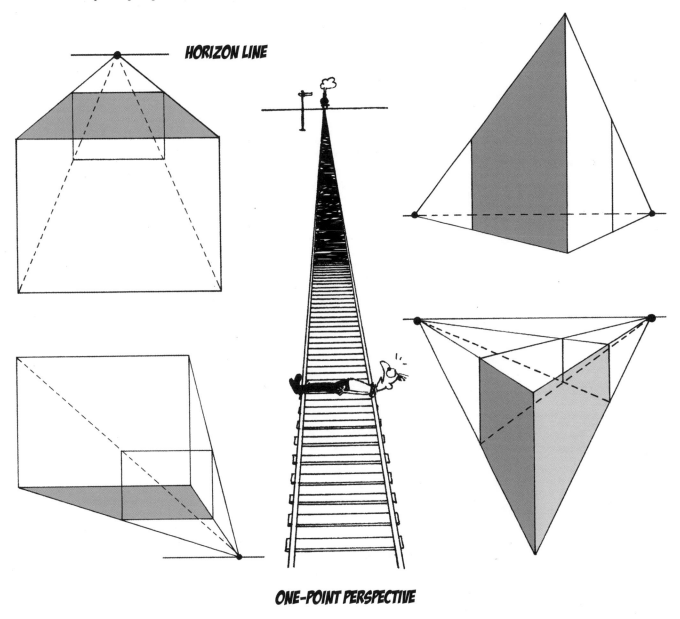

HORIZON LINE

ONE-POINT PERSPECTIVE

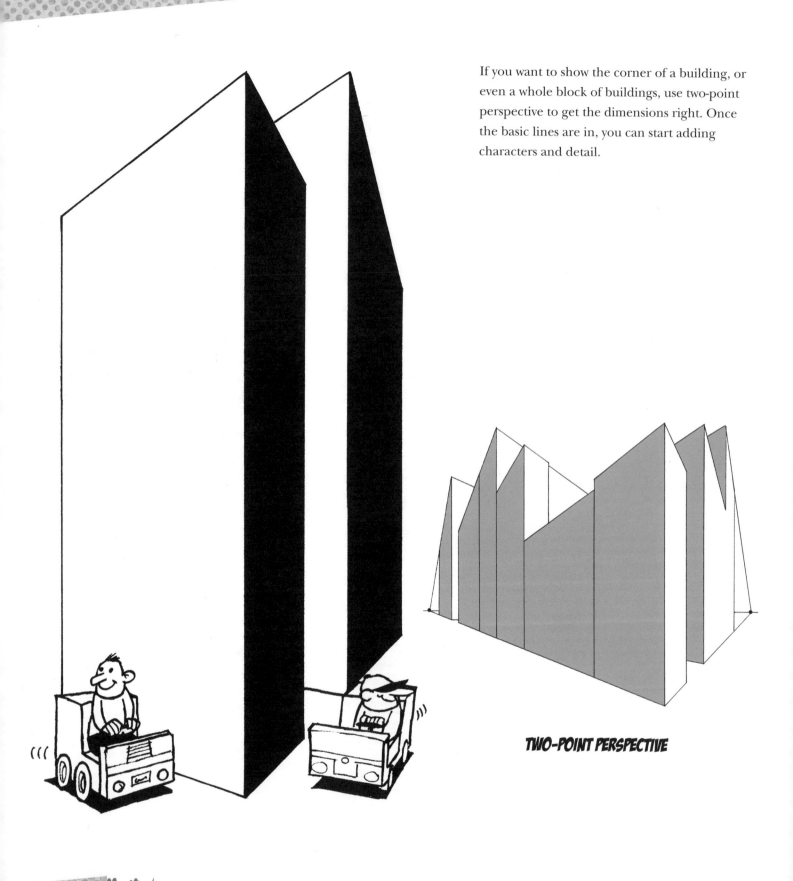

If you want to show the corner of a building, or even a whole block of buildings, use two-point perspective to get the dimensions right. Once the basic lines are in, you can start adding characters and detail.

TWO-POINT PERSPECTIVE

THREE-POINT PERSPECTIVE

The most common use for three-point perspective is to show towering buildings from the viewpoint of someone standing right underneath them.

To construct it, draw a horizon line and two points on it. Then, in any position, either above or below the horizon, make a third point (I've made mine above). Draw a vertical line straight down from your third point to meet the horizon line – this is the corner of your block. Then draw two diagonal lines down from the top point to make the sides of the block. To make the top and bottom of the block, draw three lines out from each of the side points, making them intersect at your straight vertical.

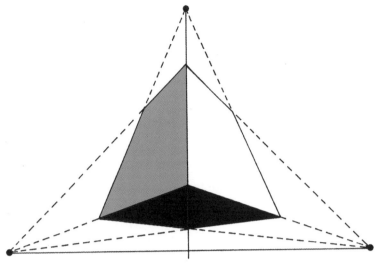

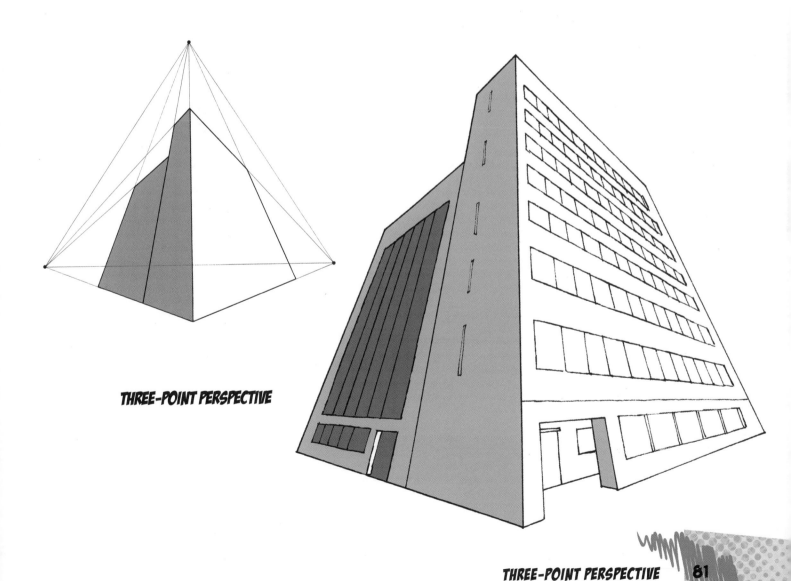

THREE-POINT PERSPECTIVE

PEOPLE AND ANIMALS

Turning to smaller subjects, let's look at the bodies of people and animals in perspective. In fact, you can use exactly the same method as for inanimate objects – the only difference is the size you are working at.

Let's take the example of a man running towards you. His head is closer to you than his feet, but where do you put his feet? There's a length of body and legs between the two. So you divide the body up into bits. Draw the head and shoulders and put in the rough position of the waist. Join up the two elements with the two guidelines and fill in the space with body.

Then draw the waist to the top of the legs, complete that, and draw from the top of the legs to the feet, and so on. Don't even attempt to produce a beautifully finished clean cartoon – just rough it with a pencil.

Next, tape your rough onto the surface of your lightbox, place a clean sheet over the top and start to progress the cartoon to a more finished stage. If it's not working, don't worry – just begin again.

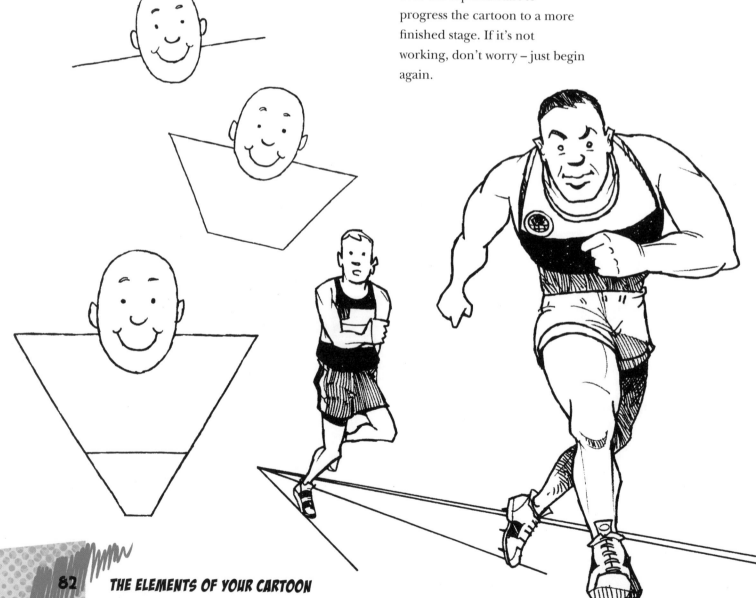

THE ELEMENTS OF YOUR CARTOON

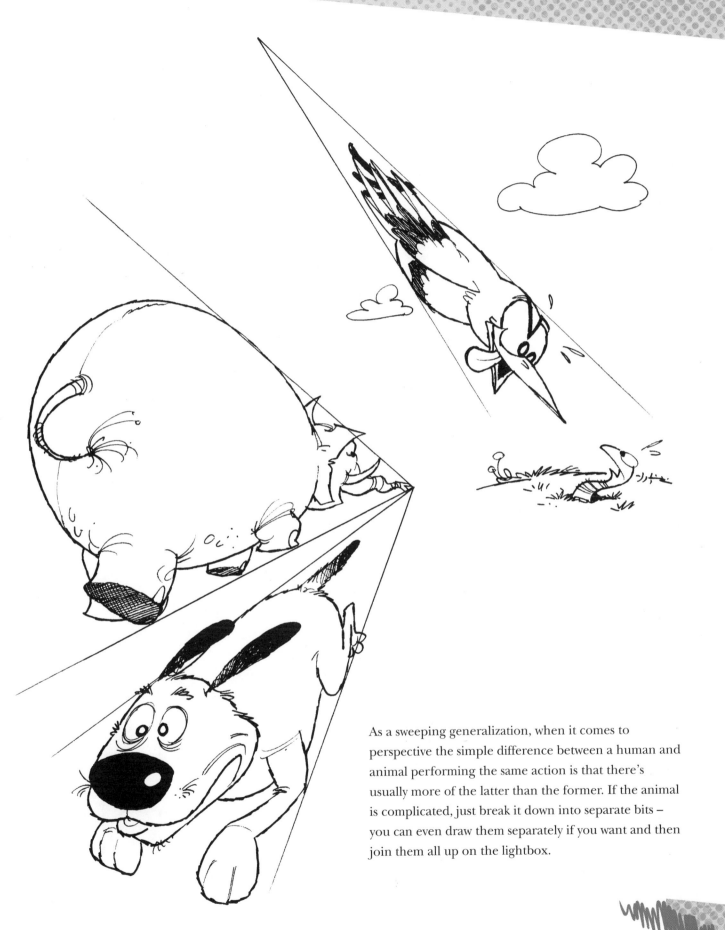

As a sweeping generalization, when it comes to perspective the simple difference between a human and animal performing the same action is that there's usually more of the latter than the former. If the animal is complicated, just break it down into separate bits – you can even draw them separately if you want and then join them all up on the lightbox.

CARTOON LETTERING

The rest of this book is largely devoted to drawing definitive types and styles of cartoons. However, before we talk about them, it will be useful for you to know how to use lettering in conjunction with the various genres, since captions and the way they are lettered are an integral part of many cartoons.

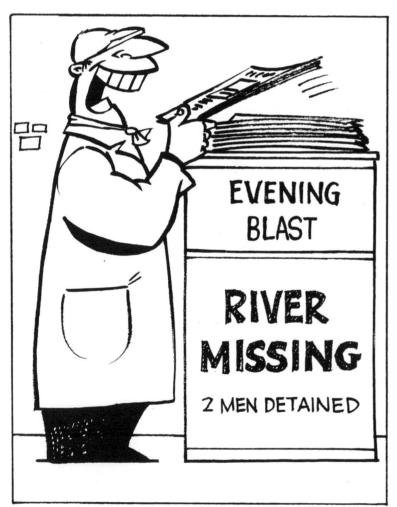

EVENING BLAST

RIVER MISSING

2 MEN DETAINED

Where cartoonists do their own lettering it becomes an important part of the overall artwork. Cartoonists often develop a style of lettering that is uniquely their own, and you may find working on your lettering as absorbing as your drawing.

Any lettering that appears within the cartoon artwork area, such as a sign on a banner, is usually lettered quite formally so it is clearly legible, using a white background as much as possible.

If you have never drawn lettering before, your best bet is to find a complete alphabet of the kind of typeface you are looking for. Most computers have software programmes with a reasonable selection of fonts included on them, so just print out the one you like and trace off the letters to assemble your wording, taking care with the spacing. As a very general rule of thumb, vertical letters should have more space between them than circles, which should be very close together, and the space between each word should be equal to one letter space, an 'O'.

GAG CARTOONS

The most common method of captioning a gag cartoon (see pp.94–9) is to type the joke under the artwork area, clear of the drawing (below). This allows the joke to be told in a fast and unfussy way. A consideration for professional cartoonists is that it also allows the joke to be translated into a foreign language if the cartoon is sold off under licence. Sometimes the caption is drawn by the cartoonist in a balloon within the artwork area (right), always lettered on a white background, again for translation purposes.

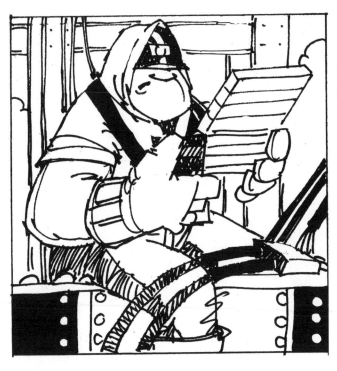

Not assiette de cochon de lait rôti et son jus de cuisson, followed by café pur arabica – AGAIN!!!

EDITORIAL CARTOONS

It's unusual to see widespread use of hand-lettering in this more illustrative kind of cartoon (see pp.100–3). Generally, any captions that are required are typed.

STRIP CARTOONS

This is the one area in which the lettering becomes an art form, with or without any pictures. In strip cartoons (see pp.104–15), three methods of lettering are generally used:

1 *CAPTION LETTERING* in a balloon
2 *SOUND LETTERING* drawn as part of the artwork
3 *CAPTION LETTERING* set outside the artwork area, under the relevant frame. This is used in conjunction with caption lettering in a balloon.

1. CAPTION LETTERING IN A BALLOON

This is the commonest form of lettering in a strip cartoon. It can be typed or hand-lettered and, as in the gag cartoon, is always drawn on a white background. If you will be hand-lettering, you will need to plan this out carefully before doing your final artwork to make sure the look of the letters fits the style of the cartoon and also that you will be able to get everything in!

Where the lettering is typed, professional cartoonists use a small number of different fonts that are generally acknowledged to be most suitable for this type of cartoon: they include Comic Sans, Chalkboard, Marker Felt, and Tekton Pro. The lettering is usually upright, or 'Roman'. However, some cartoon strips have typefaces specially designed for them.

HAND-LETTERED CAPTION IN A BALLOON

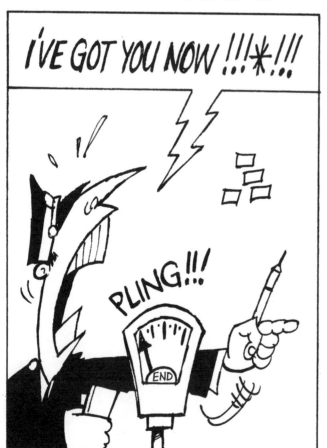

TYPED CAPTION IN TEKTON IN A BALLOON

If you want to do the lettering yourself, it's advisable to use a parallel rule (see p.12). The lettering guidelines must be carefully and consistently drawn, otherwise the words become difficult to read; captions appear quite small on the page. Draw your letters in pencil first, so that you can easily erase mistakes, then use a pen that will give you a consistent line thickness – I have always favoured a felt-tip pen for lettering. A calligraphic pen is inadvisable, as the extreme variation in line thickness won't make for good legibility. You can draw these captions all in capital letters or with capitals only at the beginning of sentences, as you prefer.

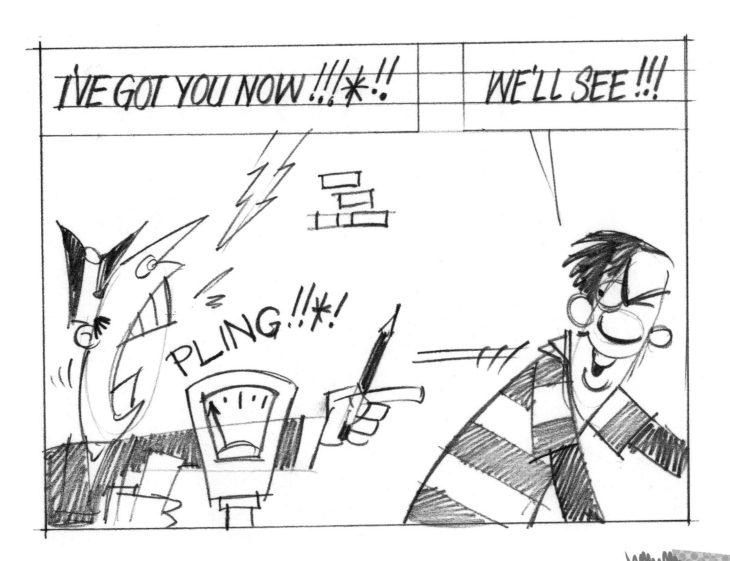

2. SOUND LETTERING

This is where you can have a lot of fun. 'Sound lettering' doesn't really say anything – it just emphasizes what is going on in the picture.

Standard words you can see used in many strips include *BLAM! CRASH! BOOM! SPLAT! SCREECH! AARGH!* The words are either associated with action of some sort or they are put in to tell the viewer about something passive, such as sleeping, snoring or glowering.

If you have Photoshop or some other image-editing programme on your computer you can achieve great results for sound lettering. Turn to pages 122–3 for more on how to use Photoshop for lettering.

Before you launch into designing some amazing outlined and shadowed lettering, you must decide whether the action demands it. Also, have you drawn your cartoon in a way that allows this lettering to blend into it? It must be part of the illustration, not an add-on. Consider the action and then decide how to letter the words that will best reflect it. There are many ways to treat just one word, so look at a selection of comics to see how other artists have handled sound lettering. You will see that it can be drawn in very inventive ways.

For example, the word **BANG** could be exploding into little bits. To do this you have to be very careful in your drawing, so it remains clearly readable. Rough out the word very quickly and then start breaking it up, always being very critical of what you are doing and firmly stopping yourself from going over the top and allowing it to turn into a confusing mess. A good test is to ask someone if they can read it. If it's too complicated, start again!

BANG

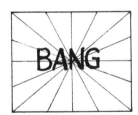
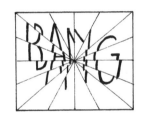

So the three friends, tired out by the events of the day, gathered their things together, and walked slowly homeward.

3. CAPTION AND BALLOON LETTERING

This technique is used when the story is recounted under the frames of the strip cartoon and the dialogue is set in speech balloons within the frames. It comes into its own when a complicated story has to be turned into strip form. This lettering is not often done by hand, so you can follow the example shown here and simply type it.

SPECIAL EFFECTS

You can have great fun creating special effects for your cartoons and they are a good way to show things visually rather than writing them in captions. Someone has an idea? A light bulb will do the trick. They're sneaking around in the dark? Show them in silhouette. Explosions, lines of movement, fight clouds, dizziness, the list of effects is endless.

GAG CARTOONS

This term describes the one-off cartoons that crop up in newspapers and magazines. They are widely used, covering any topic, and either have a simple punchline or are purely visual jokes. Although they are drawn in a variety of styles, the overall effect does lean towards a relaxed, casual drawing. As they are usually small, and are single-framed cartoons, they have to deliver the joke quickly and simply.

Cartoon gags are usually divided into categories such as the Nosey Neighbour, the Angry Housewife, the Drunk, the Boardroom, the Socialite, and so on. A different category is the political one-off. I have always greatly admired the cartoonists who deliver these as they have to come up with good material day after day, commenting on events that have only just occurred. It's not as easy as they make it look!

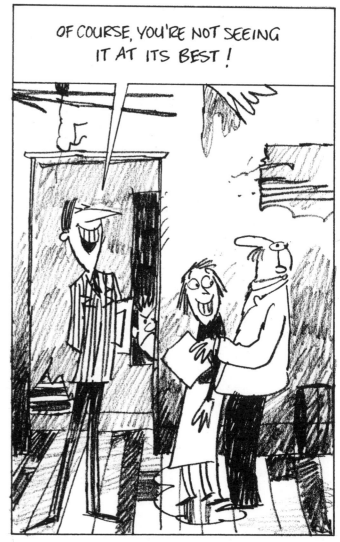

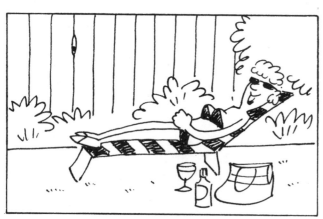

'MORNING, Mr Weber!

Because of the spontaneous way in which gag cartoons are drawn, use a pen or pencil that will allow you to get the necessary relaxed effect. A felt-tip pen will give a good black line and let you scribble away very quickly. Never discount your first scribbles – very often when you're relaxed you can catch a look or an emotion that is very difficult to replicate and is often good enough to do the final job. You can put the cartoon into a formal box frame or just leave the borders of the drawing to fade out, a style known as a vignette.

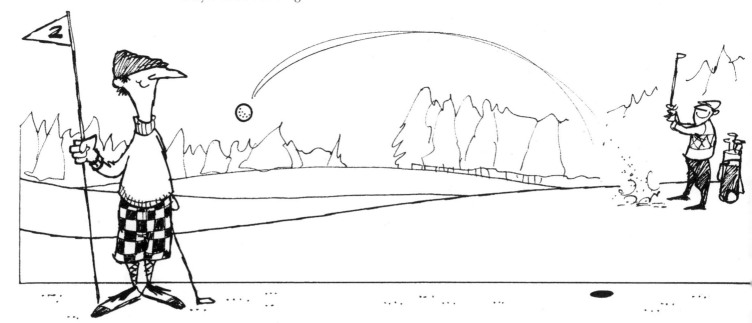

If you want to colour the cartoon, do it in way that matches your style of drawing, always remembering to keep it simple. However, most cartoons of this type are drawn in black and white. You can add a grey wash to the drawing, but only do so if it's going to add something to the overall effect.

DON'T FAWN JOHNSON!

Mum and dad
2 kids - girl
and boy, pet -
cat or dog ?

The way to come up with ideas for this type of work is very much up to the individual, and I can't give you a thought pattern that will work every time. However, there is one method you can apply that might get you thinking in the right way. Have a look at the following examples.

Take any scene, for example the familiar one of the domestic morning rush, where kids and parents are scrambling to have breakfast and make their lunchtime sandwiches at the same time. In the confusion and the

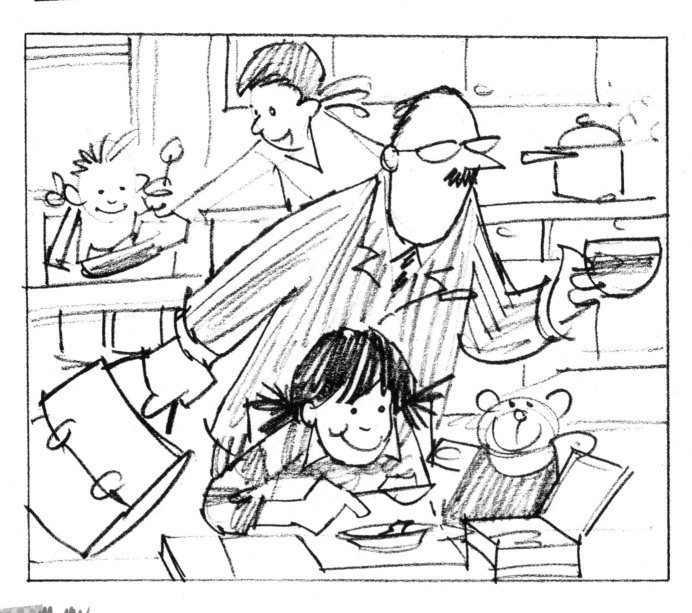

haste to get out of the door, dad has picked up his four-year-old's lunch pack by accident. Picture him, the big executive, at his desk, drinking out of a non-spill mug in the shape of a rabbit and eating chocolate buttons. He has to explain it away to his secretary, who is looking highly dubious! It's not a brilliant idea, but it's simple and easily drawn, and many people will recognize the silliness of the gag with perhaps a wry smile, as it might have happened to them.

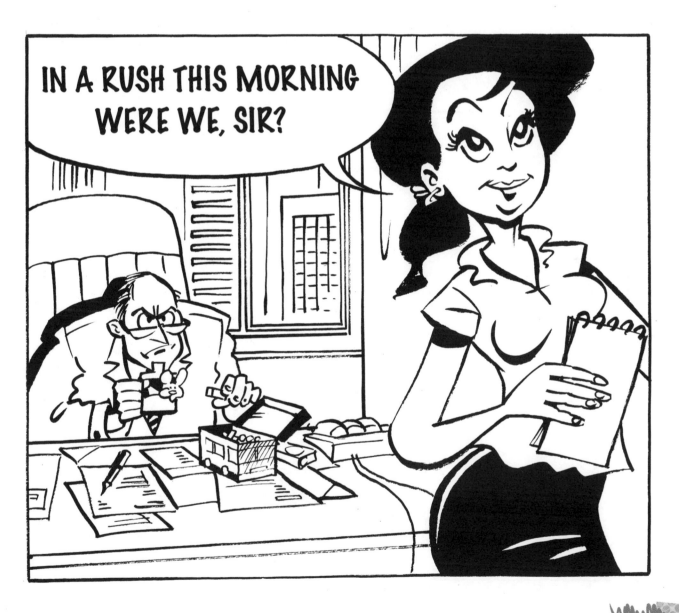

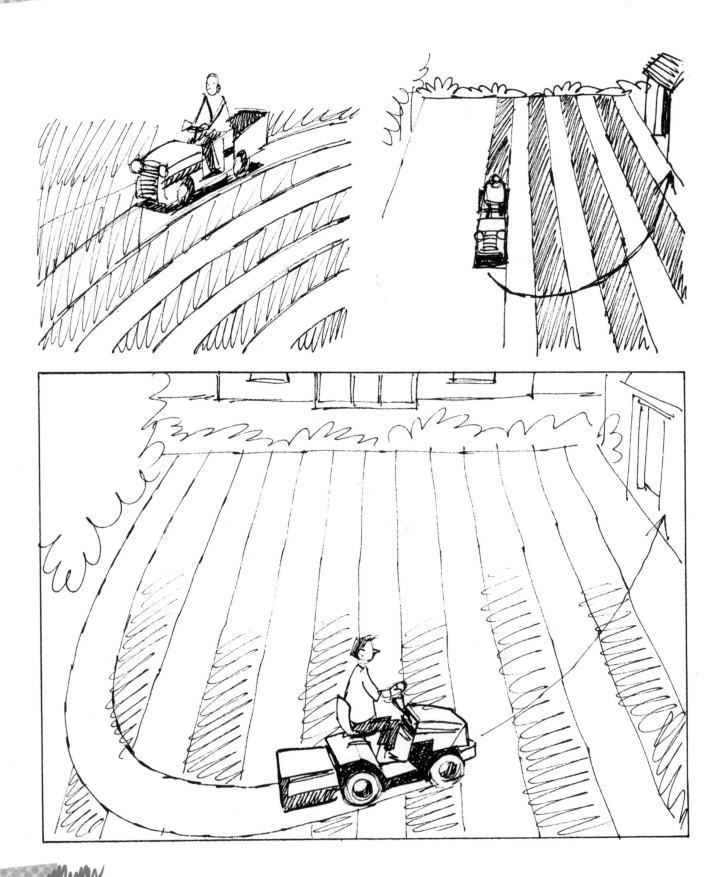

DIFFERENT TYPES OF CARTOON

Here's another example: this time I decided to have just one character, out in his garden. I've always wondered how lawns can be so perfectly mown in straight lines. So I played around with this idea until I came up with my gag.

The secret of dreaming up a cartoon like this is to take the first situation that comes into your head and give it a little twist, and that's what makes the gag. One tip here: if you think of a funny idea and have to struggle to make it work on paper, abandon it. It happens quite often that what sounds funny doesn't necessarily work as a drawing.

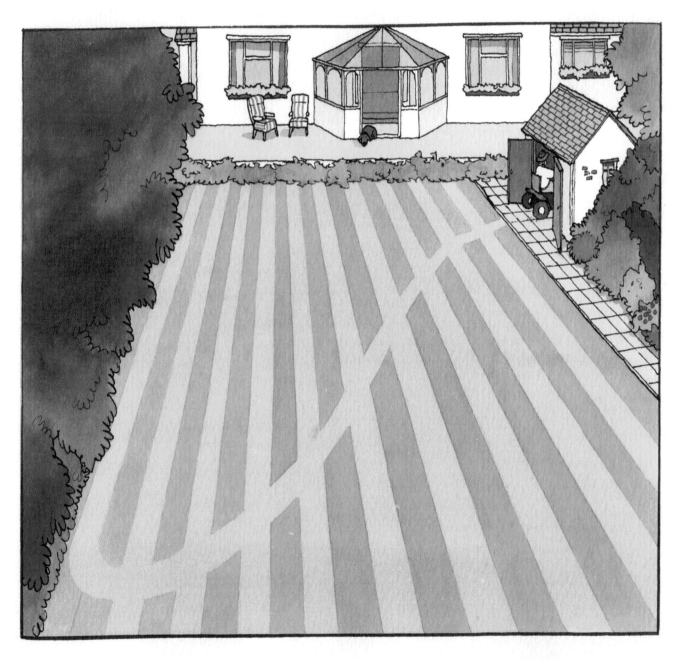

EDITORIAL CARTOONS

This type of cartoon is often more sophisticated than the gag style of drawing. They are usually placed in conjunction with an article in a magazine or broadsheet newspaper. While they may sometimes have punchlines, more often they do not.

Editorial cartoons can be created in any medium, from pastels to oil paints, acrylic paints or montage – just about any way the cartoonist sees fit. Some artists draw straightforward cartoons such as you would see in a comic book, while others produce very unconventional work that really does push the boundaries of illustration as far as possible. These cartoons can even be charts or diagrams, but executed in very imaginative ways.

These examples show two very different approaches to the public's perception of bankers. The cartoon on this page is of a Fat-Cat Banker, drawn in a contemporary style.

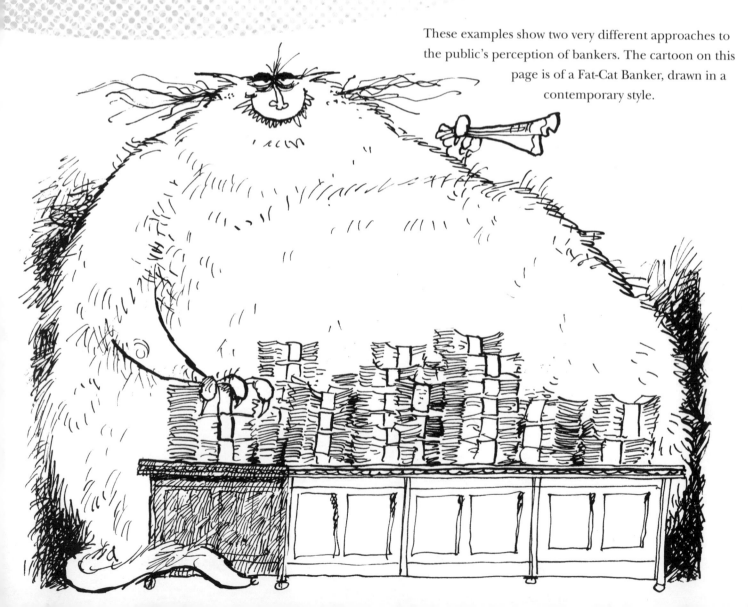

This is a much more traditional cartoon, showing a
banker using trickery to cheat people of their money.
The style is reminiscent of 19th and early 20th century
political cartoons.

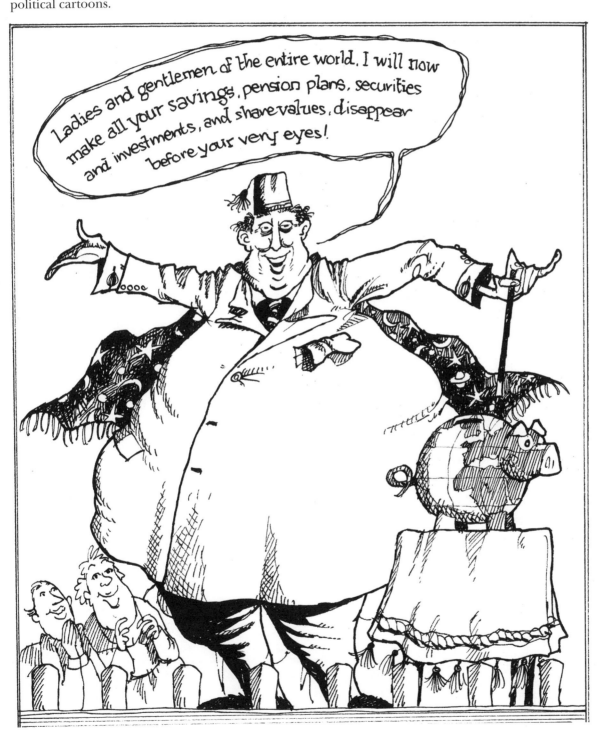

CREATING AN EDITORIAL CARTOON

Editorial cartoons are of course linked closely to the text they support, so the first thing to do is to read the article carefully, looking for the trigger that will give you your idea.

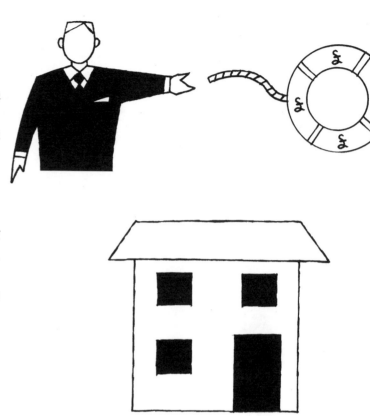

Let's take the theme of conservation, something that we read about almost every day. This imaginary article tackles the issue of people losing their homes due to land collapse at coastal locations. Now think yourself into the position of a professional cartoonist who has been briefed to provide a visual comment on the lack of action by central government concerning a coastal area. If the government were helping, this might be called throwing the affected households a lifeline. But they are not, and this is the centre of your idea – the government, holding a lifebelt which is attached to them by a rope. The lifebelt has been thrown, but the rope has either gone with the lifebelt or has snapped, thereby making the so-called help totally ineffectual.

So now you have to put pen to paper. Rough in the two elements of the story – the government throwing the lifebelt and the family in trouble on the cliff edge. Sometimes figures in this kind of cartoon are actually labelled, in this case 'Government' and 'Victims' or some other suitable phrase. This technique can look a bit dated, so you must use your judgement on this point.

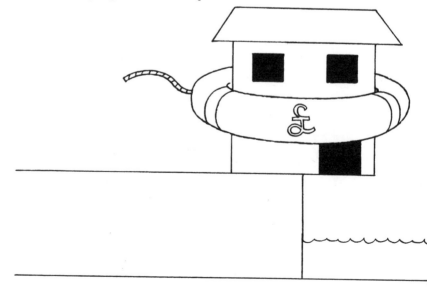

Before you do your final cartoon, there is another factor to consider: should the drawing be realistic, stylized or surreal? Here you would probably go for stylized, as this technique would allow you to tell the story more clearly in what would most likely be the small space allowed.

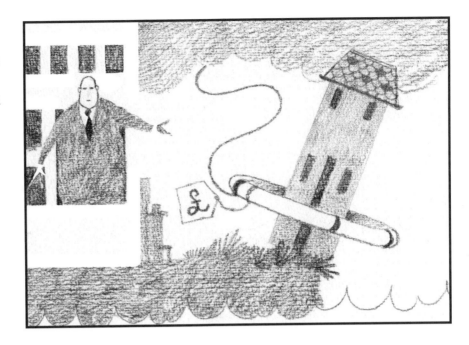

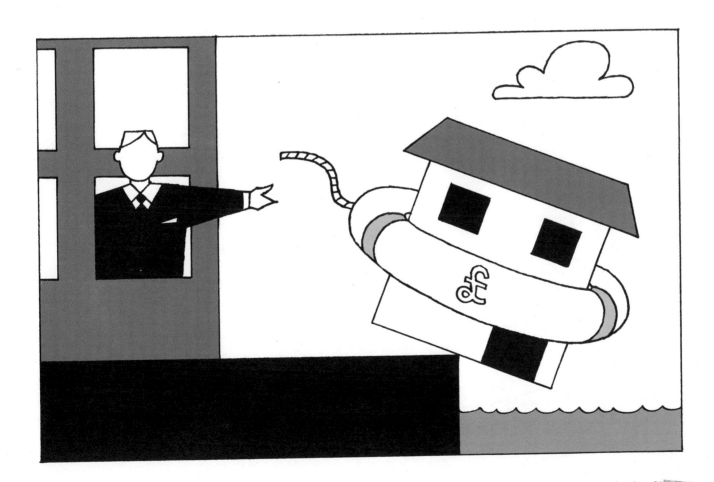

STRIP CARTOONS

The world of the strip cartoon is entirely different from any other form of cartooning, with its own set of rules and techniques. A strip usually takes the form of a series of panels telling a simple story that often ends with a joke or punchline, and there is usually a recurring central character or characters.

In this section I'm going to describe the steps it's prudent to take before you even begin to draw your strip. However, rules are there to be broken, so I am going to tell you all the rules, and then I'm going to tell you how to break them!

RULES AND REGULATIONS

The heading to this very important section doesn't sound very creative but, strangely enough, these rules are here to allow you to be as creative as you want to be. Try to apply them to everything you do at the start of a new strip – as you will see, it'll make life very much easier for you.

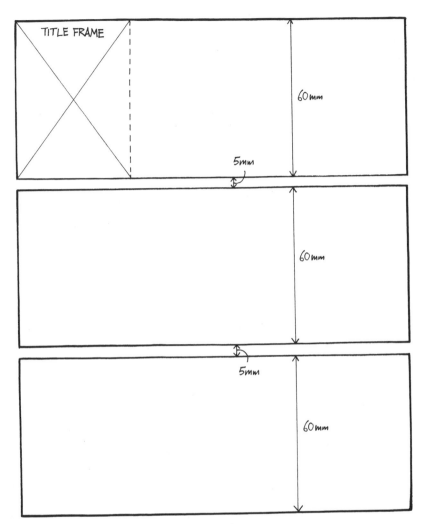

TITLE FRAME

60mm

5mm

60mm

5mm

60mm

The first thing you need is a grid or template, carefully measured so that you have a number of frames that match in size. This template must be used on every page you draw as you work your way through the strip. If you have a title to put in, either place it along the top of the page or use the first frame.

If you want to create a title for your strip, it can be contained in the first frame as in the template above, but it can also run across the top of the entire page, or even vertically down one side of the strip. In these examples I have shown just the names of the two cartoon heroes, but drawings of the two characters can be included. With well-known strips such as *Peanuts* or *The Simpsons*, the title becomes a familiar logo.

WRITING THE SCRIPT

Most cartoonists working on a strip cartoon collaborate with a writer, but if you can think of characters and write a good script yourself, all the better. If you ever work for a publisher, there may be up to five on the team – the editor, the writer, the artist, a lettering artist and a colourist. However, I think it's much more fun to work independently.

The script should be as simple as possible, and that means one main character, or maybe two. We are going to draw a simple 3–4 frame strip of the kind you can find in any newspaper or magazine.

Write the storyline first, then put in the dialogue. For the latter, write as little as possible, then cut what you have written by half, and then cut what remains by half again! You must remember that you also have pictures supporting the words, and in reality it is the pictures that should tell the story.

SAMPLE SCRIPT

This script is a typical example of how you should plan out your strip cartoon. The strip is about two dogs – Fish and Chips. Fish is a very obedient dog; Chips isn't.

The story is that the two dogs are out walking. It is very muddy and wet. Chips loves this and jumps in and out of puddles, getting into a terrible mess and thoroughly enjoying himself. Fish hates it all and comes home as clean as when he went out. However, Chips covers him in mud when he shakes himself, so they are both in disgrace.

FRAME 1
Chips and Fish are out in the rain. Chips is jumping in a huge puddle. Fish is looking on in disgust.
CHIPS Great, I love this weather!

FRAME 2
Fish is standing well back while Chips rolls in a puddle
FISH Well, I don't.

FRAME 3
They are both at home now and Chips is shaking mud all over Fish.
CHIPS Now to get dry.
FISH Ugh!

FRAME 4
Their owner is sending them outside again because they are both so bedraggled.
FISH Now we're both in a mess.

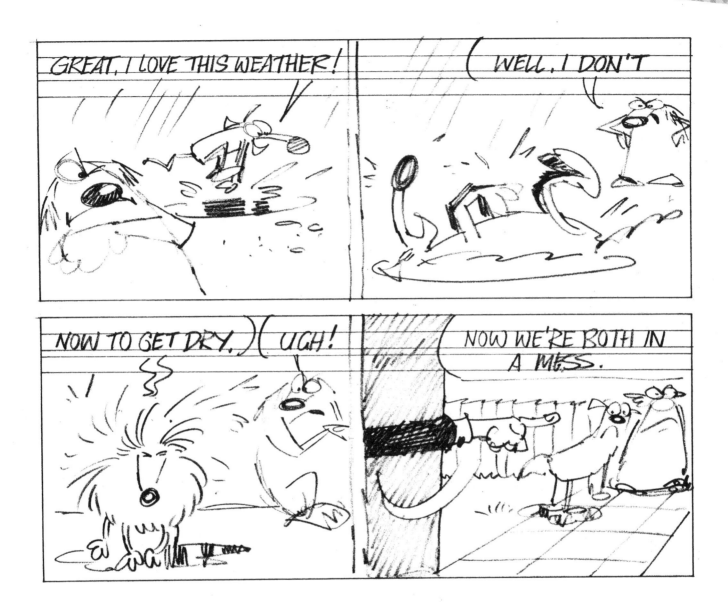

BACK TO THE RULES AND REGULATIONS!

At this stage, it's best to draw in guidelines for the lettering. Unless there is a lot to get in, try to keep the dialogue to the top of each frame. If there isn't enough room at the top, then use the bottom of the frame for any extra balloons, keeping the centre of the frame clear for the drawings. If possible, try to have a sequence of 'question and answer' just once in every frame, as more can look confusing and crowded.

Keep the action moving from left to right the way we read, by lettering the speech in the correct order.

CHARACTERIZATION

Now is the time to establish the drawings of the characters. Try to make each animal or person clear and simple, giving them some distinctive aspect that makes them easily identifiable. A good way to test this is to draw them in silhouette – if each character is immediately recognizable, you've succeeded. Make a clear drawing of them on a separate piece of paper and then keep that as your reference.

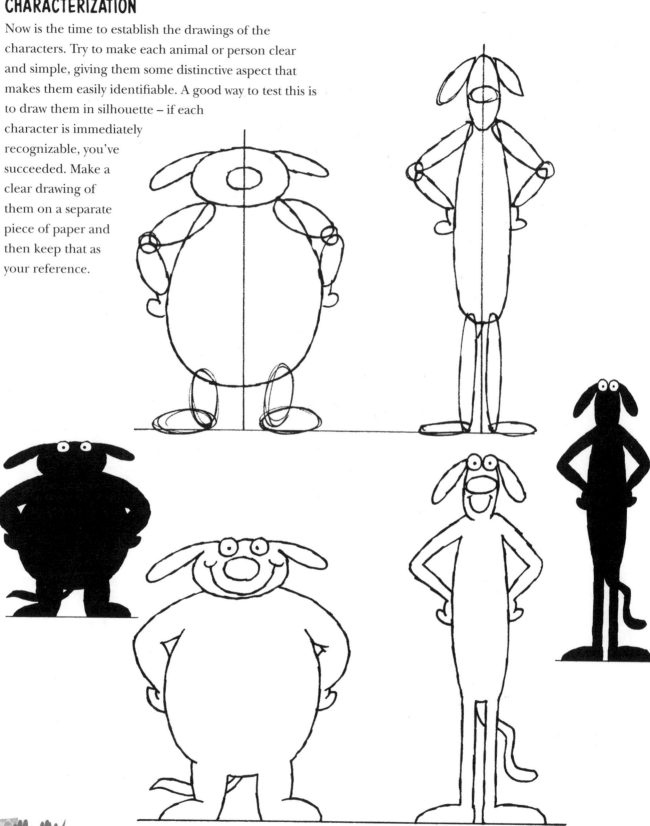

DIFFERENT TYPES OF CARTOON

FiSH AND CHiPS

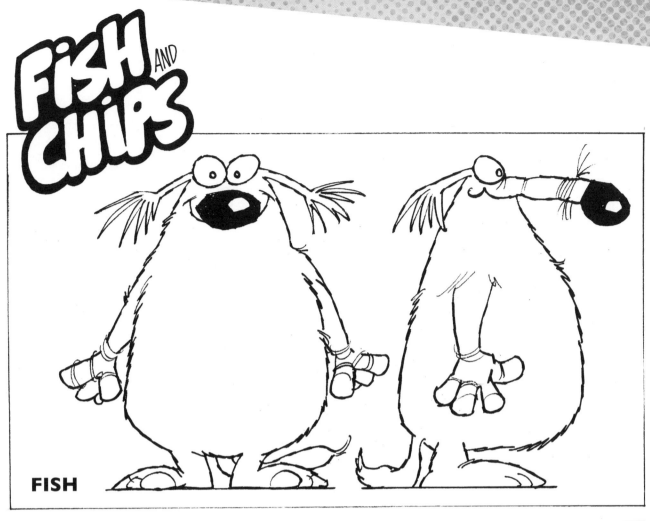

FISH

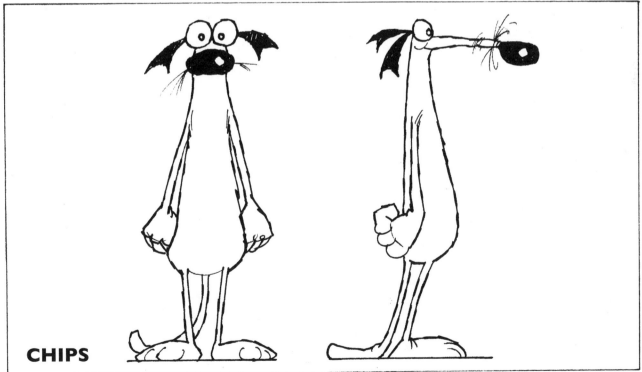

CHIPS

GET DRAWING

This is where the fun starts! If you asked ten different artists to draw this strip, you would get ten totally different results. I can only give you a few suggestions about how to begin and the different avenues that are open to you.

Decide how you are going to place each frame in the horizontal rows. I suggest that when you are setting the scene you give more space to it than you would allow for just an exchange of dialogue. What you actually draw is laid out in the script. Imagine the scene, and then use the 'roving camera' technique described on page 70.

When you have decided on the best angle, rough it out, keeping the detail well away from the speech balloons. Ask yourself over and over, 'Does what I'm drawing tell the story?' Don't forget continuity – if you are going to repeat a drawing, for example the path where Fish and Chips are walking, the details must be the same every time you draw it, no matter what the angle. This also applies to colouring.

It's important to draw the main characters as soon as possible to establish who they are. You'll find you soon get used to drawing them.

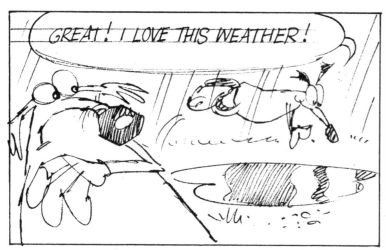

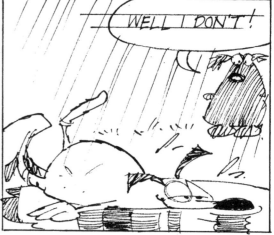

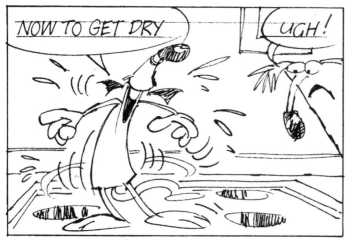

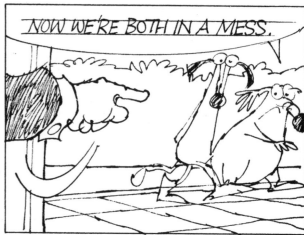

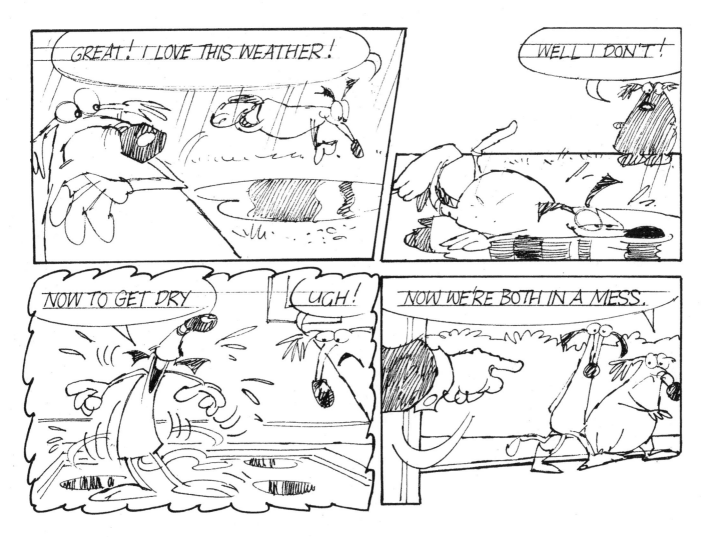

Now we have reached the stage where all the frames are in place and the lettering has been pencilled in. There is, however, one more stage before we start inking, and this is when you get to break, or at least stretch, the rules.

Look at the strip and ask yourself if the action that's going on in the frames can be enhanced. There are many ways to achieve this, but remember that more is not always the solution. The first frame is a scene-setter, so perhaps this could be the largest.

It's not always necessary to have all four sides of the frame drawn in. Removing them can open the picture up and get rid of the enclosed feeling of a complete frame. You can use circles or even leave the frame out altogether – but be careful if you do this, as the end result can be confusing if you make it too jumbled.

INKING IN

It's always best to use black ink rather than black pigment when you are inking the strip. If you are going to scan your artwork, I suggest using a felt-tip pen. Then you scan it in such a way that the felt-tip colour will appear as solid black (see page 118).

If your work isn't going to be scanned and printed it's best to use black ink – if you use a felt-tip pen, the line will appear grey, lacking the impact of a solid black. Winsor & Newton produce an excellent black ink which is totally waterproof – an essential point. In the past I have fallen into the trap of accepting a manufacturer's promises regarding an ink's waterproof qualities, inked

a whole page, started colouring, and found the black in fact very far from waterproof.

The two most usual ways to ink in are by using a dip pen or a brush. Both techniques need practice. The generally accepted way of inking is to draw a smooth line of variable thickness, which can be achieved with both tools. If you're going to use a brush, be aware that if you pick a big one the variation in line thickness can be greatly exaggerated and you also might not be able to put in small detail. As a general tip, I find that a smaller size brush is better to begin with. If you do decide on a brush, you can cut the bristles to suit yourself – you may, like me, prefer a blunter end.

When you've finished off the inking, clean away all the pencil. It's easier to fill in the solids and tones after you've done this, as you can see the drawing more easily without all your pencil marks. As described on page 18, use an overlay or make a copy of your inking and roughly fill in where you think you want your blacks and where the midtones will go. As you gain in experience, you'll be able to see where you should place the blacked-out areas without doing roughs.

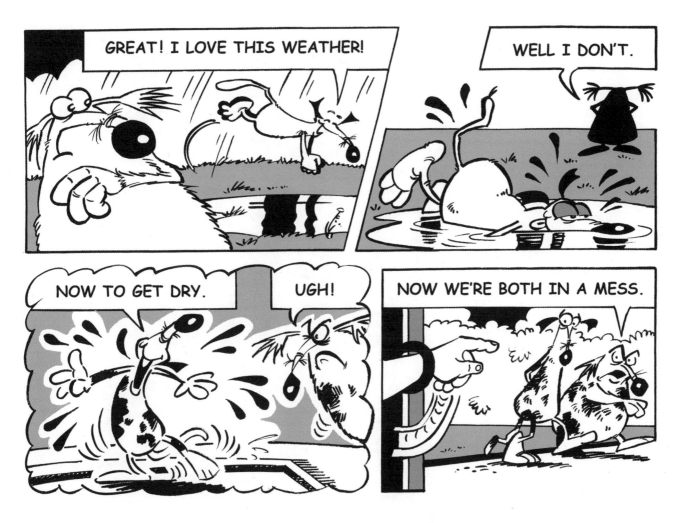

COLOUR

If you're colouring up the artwork, the main
thing to remember is continuity. You already
have master drawings of the two main characters,
and you should always have them in front of you as
you colour. Apply the colour in two stages: first the
characters and the main items that appear in the
strip, then the backgrounds.

Some cartoonists use the method of never
changing the light on the colouring of the
foreground figures but very obviously changing the
background colouring according to the time of day,
or the situation the foreground
characters find themselves in. The
other way to use light is to change the
colouring of the foreground figures as
a reaction to what's going on around
them. This could be backlighting,
silhouettes, an overall single colour to
denote night-time, for example.
Again, experimentation and
experience will allow you to draw very
exciting effects.

DIFFERENT DRAWING STYLES

There are no rules as to which style you should use for strip cartoons. However, it's generally accepted that a certain artistic style matches a particular genre of cartoon: superheroes, science fiction, humorous, children's, underground and so on all have their own particular look.

Copying these established styles will give you an excellent starting point. As you gain in confidence and experience, you will find that you begin to adopt your own style, rather as handwriting develops over the years. The same applies to lettering the speech balloons. As long as what you letter is legible, you can adopt any style that matches the drawing.

COMPUTER TECHNOLOGY

USING TECHNOLOGY IN CARTOONS

A great many books have been written on the subject of computer software and peripherals by experts in their use. I make no claim to be one of these experts, but I can describe how I use a computer to help me draw and deliver my cartoons.

I have never had any training in the use of computers – I have simply picked things up as I have gone along, and I have also picked other people's brains. I use my computer to scan, save and send my cartoons, and to retouch and colour them in very simple ways.

I use Photoshop on a Mac and have a scanner, a printer and a drawing tablet. I find that using a pen on a tablet is very accurate, allowing you to work in great detail – a mouse is too clumsy a tool. I've also found that it's easiest to have as big a monitor as possible. To save a lot of grief if my computer crashes, I back up everything on an external hard drive as I go along. Sending your artwork to a client or friend can be done by email, if the files are small enough, or via an ftp site if you have a large amount of artwork to send. There are several ftp sites that offer a free service up to a certain amount of megabytes, and past that number the charge is very small.

SCANNING

Scanning a piece of artwork is relatively simple, and your scanner software will probably come with a PDF of basic instructions. Through a great deal of trial and error, I've found a few crafty tricks which I hope may be useful to you. I have talked about the fact that drawing with a felt-tip pen, which I do a lot of the time, produces a grey line as opposed to a true solid black line (see page 112). However, if you scan your felt-tip drawings as a bitmap with a setting of 600dpi (dots per inch), the line naturally appears very black. You can then convert the bitmap to greyscale and reduce the dpi to a more standard 300 which also reduces the size of the file. You will end up with a good strong black line which any art director would swear has been drawn with black ink. If you are scanning a halftone cartoon (see opposite), greyscale 300dpi is a normal setting.

LINE AND HALFTONES

A line drawing is just what it says it is – a drawing using only solid black lines. A toned effect can be achieved by cross-hatching or stippling, but this will still be a line drawing.

In a halftone drawing, there is continuous gradation from one tone to another. Pencil drawings, pastels, watercolour washes or any kind of illustration that has the use of line and gradation in whatever form is classed as a halftone.

This is a very important distinction. I once drew the illustrations for a book using black felt-tip pen, meaning the illustration to be solid black. When the printer saw it, he thought it was grey line and scanned it as grey line, thereby producing a halftone effect. The printed version looked very strange as parts of the drawing broke up and disappeared!

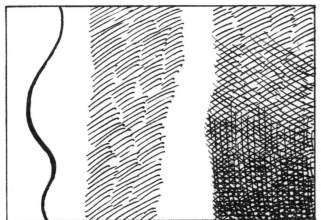

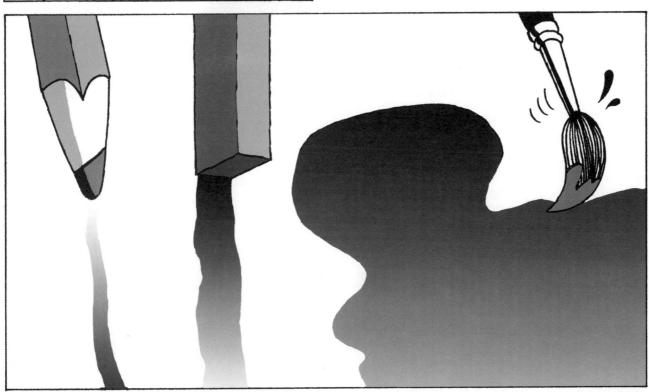

WORKING IN PHOTOSHOP

The first thing I always do is duplicate my image. I have a habit of clicking on something I shouldn't, usually causing my work to be lost! I delete any dust or dirty marks from the illustration by using the pencil or brush tool (set to the right colour), and then crop it down as tightly as possible. This helps reduce the file size. If you know the final size you want your cartoon to be, then go to Image Size under the Image dropdown menu, and put in the finished size either in centimetres or millimetres. You can also check you've got the correct image resolution (dpi) while you're about it. Finally, save it.

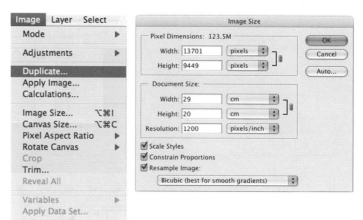

LAYERS

The Layers function in Photoshop allows you to move artworks around and copy them on to new backgrounds. If you want to move part of a cartoon, first duplicate the whole cartoon on a new layer (under drop-down menu Layer, choose Duplicate Layer **1.**). Then, on the duplicated image, select the Magic Wand tool from the toolbar and click in the background area away from the cartoon (**2.**). Your image will be surrounded by a shimmering dotted line which means it is active. Choose Inverse from the Select menu to make sure you capture just the image and not the background too (**3.**). Then you can choose the Move tool to move your cartoon, (**4.**) or copy and paste it on to another background. To save your new image, under the drop-down menu Layers, click on Flatten Layer.

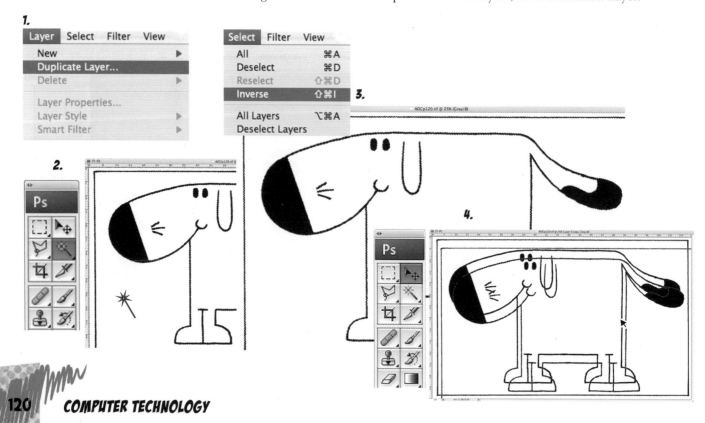

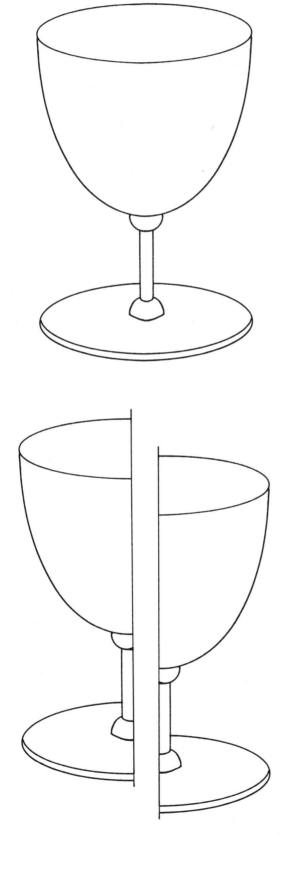

SYMMETRY

I have always found it tricky drawing objects that are symmetrical, for example drinking glasses – I can never seem to get them to look right. If this applies to you too, draw half a glass, scan it in and make a duplicate image. Go to the Image drop-down menu, and under Rotate Canvas, you'll see Flip Canvas Horizontal. Move the flipped image as I have described, taking care to make the join exact, and everyone will think you are a master at drawing these tricky objects.

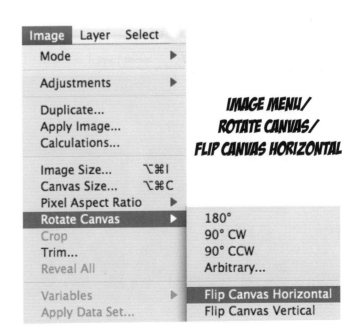

*IMAGE MENU/
ROTATE CANVAS/
FLIP CANVAS HORIZONTAL*

HORIZONTAL TYPE TOOL

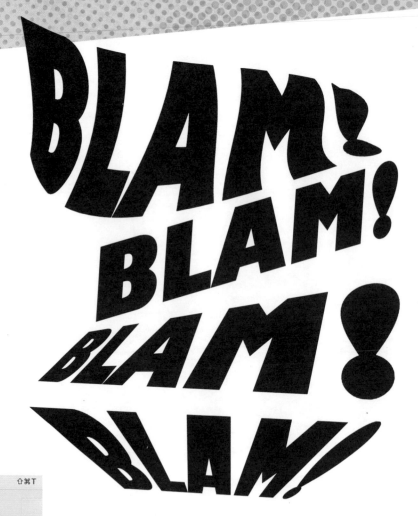

Edit	Image	Layer	Select	Filter
Undo Rectangular Marquee				⌘Z
Step Forward				⇧⌘Z
Step Backward				⌥⌘Z
Fade...				⇧⌘F
Cut				⌘X
Copy				⌘C
Copy Merged				⇧⌘C
Paste				⌘V
Paste Into				⇧⌘V
Clear				
Check Spelling...				
Find and Replace Text...				
Fill...				⇧F5
Stroke...				
Free Transform				⌘T
Transform ▶				
Auto-Align Layers...				
Auto-Blend Layers...				
Define Brush Preset...				
Define Pattern...				
Define Custom Shape...				
Purge ▶				
Adobe PDF Presets...				
Preset Manager...				
Color Settings...				⇧⌘K
Assign Profile...				
Convert to Profile...				
Keyboard Shortcuts...				⌥⇧⌘K
Menus...				⌥⇧⌘M

Transform submenu:
- Again ⇧⌘T
- Scale
- Rotate
- Skew
- Distort
- Perspective
- Warp
- Rotate 180°
- Rotate 90° CW
- Rotate 90° CCW
- Flip Horizontal
- Flip Vertical

EDIT MENU/ TRANSFORM

RECTANGULAR MARQUEE TOOL

LETTERING

There's a wonderful facility in the toolbar called Horizontal Type Tool which allows you to typeset all your own cartoon lettering. If you look at the bottom of the toolbar you will see two small overlapping squares. These are your foreground and background colours. Make sure that black is the foreground colour, and then you can start lettering.

Let's take the word BLAM!. Set that in a good strong typeface. Mask a tight area round the word, using the rectangular marquee tool. Go to the Edit drop-down menu, and click on Transform. There you will see various tools such as Scale, Distort and so on. Click on the one you would like, and from there on you can have great fun doing almost anything with the lettering. Go mad to begin with, and see what these tools let you do – the only proviso is that you can read BLAM! clearly. Click on the rectangular marquee tool again, click on the Apply box which will appear, and that's it.

If you have drawn a cartoon and you want to typeset a 'sound word' as part of the cartoon, then you scan your cartoon – in this case the dog – on to a new file that's big enough in area to take both the drawing and the word BLAM!.

In the new file, position the dog well to the left to allow space for the lettering.

Then move the word on to the same file. If you move your cursor around the active area, the cursor will show different icons, which tell you what moves you can make:

Rotate
Condense/expand the image
Cut and paste
Move the image after it has been pasted
Enlarge/reduce the image in scale

When you are sure you have both images in the correct position, the job is done. At this point you can flatten the image if you want.

 ROTATE

CONDENSE/ EXPAND

CUT/PASTE

MOVE AFTER PASTE

EXPAND IN SCALE

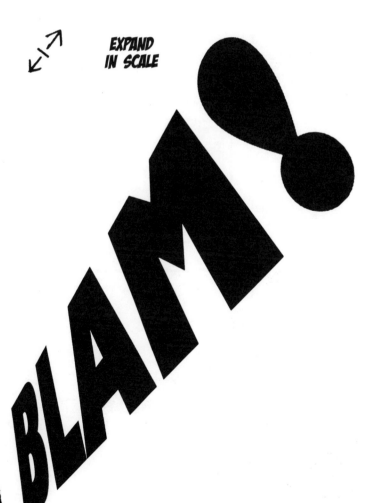

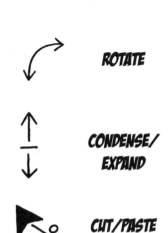

ADDING COLOUR

There is a very simple method for colouring your work quickly; in your drawing stage, just make sure all the lines that go to make up the cartoon are joined up, without any gaps. You can then drop colour into each of these areas.

After scanning in your line drawing, click on the foreground/background colour boxes and a Colour Picker or Colour Library box will appear. Decide which of the two systems you feel happiest with, and click on a colour. Don't worry if it looks wrong at this stage.

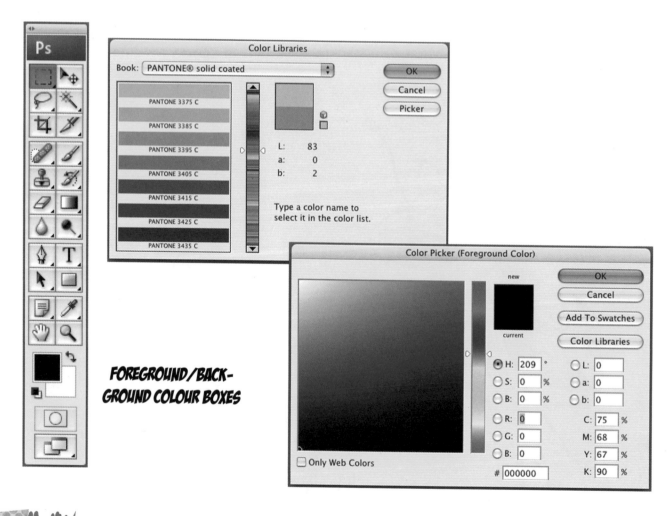

FOREGROUND/BACK-GROUND COLOUR BOXES

Then, using the paintbucket tool, click on the area you want to fill. Simple! If the colour looks wrong, go back to the colour charts, click on a colour you think may be closer to what you want, then back to the cartoon, and click paintbucket over the colour you want to replace. The new colour will appear.

If you want to repeat a colour you have already used and can't remember what it was, use the eyedropper tool, click on the colour you want to replicate, and it will appear in your foreground colour box. Use the paintbucket tool, and the correct colour will be repeated.

If you make a mistake, go to the Edit dropdown menu and click on Undo or Step Back. You may have a small break in your lines. Using the navigator option under the view menu, enlarge the area to find the break and fill it in with the pen tool.

This method only scratches the surface of colouring techniques, but it will get you started, and you might wish to push your digital experimentation into really sophisticated work.

PAINTBUCKET TOOL

EYEDROPPER TOOL

EDIT MENU/ UNDO OR STEP BACK

Edit	Image	Layer	Select	Filter
Undo Pencil				⌘Z
Step Forward				⇧⌘Z
Step Backward				⌥⌘Z
Fade...				⇧⌘F

PEN TOOL

NAVIGATION PANEL

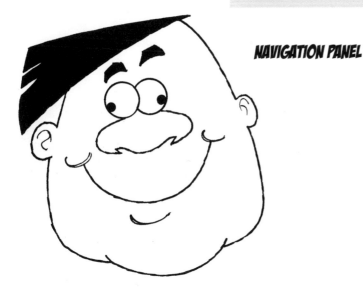

CONCLUSION

Drawing cartoons is a wonderful way of spending your time – I always considered myself very lucky to have such a great job. In this book I have tried to cover most aspects of cartooning, and I hope that the information I have given will help you to push your art forward. Some I have picked up from friends and colleagues and some I have gained through experience, which includes making many mistakes! In this business I am always learning, and seeing what other people are doing can be a valuable influence.

My final advice is to always be observant of what's going on around you so that you have plenty of ideas and to commit yourself to your art. Come on in everybody, the water's great!

CARTOONS

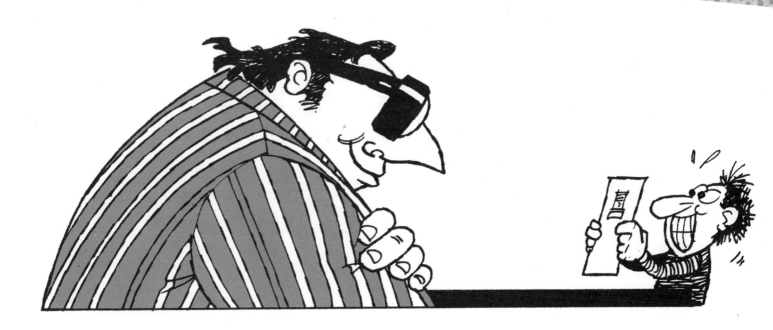

TAKING YOUR WORK FURTHER

If you want to try to sell your cartoons, there are many outlets open to you and the route to follow is a fairly simple one. First, look at magazines that use cartoons. On their contents page you will find a list of the staff, and you can work out from this who to send your work to. However, contact them before doing so to check how they would prefer it to be submitted. If you want to sell a strip idea you can either go straight to the magazine or newspaper or find a syndication agency to market it.

Agents will represent you to anyone who is interested in your work and take a commission from every sale they make. There are specialist agents dealing with cartoonists, but if you sign up with one of those you will be in competition with all their other clients, who will be doing similar work to your own. Instead, try to get on to the books of the most reputable illustrators' agents you can find, regardless of the kind of work they represent.

Cartoon websites will also sell your work for you. All you need to do is send them samples, and if they agree to take you on they will put your work on their site; if any of your work is sold, they will take a commission.

These outlets usually only accept gag cartoons. There's no doubt that marketing via your own website instead can be very successful, but there are so many sites out there all selling the same basic items that you will need to think of a way to make yours stand head and shoulders above the rest.

Greeting card companies are a good source of work. Some will accept only one or two samples if you present them with a selection, while others will take you on as a freelance employed on a fairly regular basis. The latter will usually send a brief which you then have to illustrate in a particular way. This doesn't offer much room for imaginative work, but it does provide you with a regular fee.

There are also hundreds of graphic design studios, designing a wide range of work. Because of the very broad market they work in, they offer opportunities to cartoonists of all types, and are usually very receptive to new talent.

INDEX